# Layered Textiles

Kim Thittichai

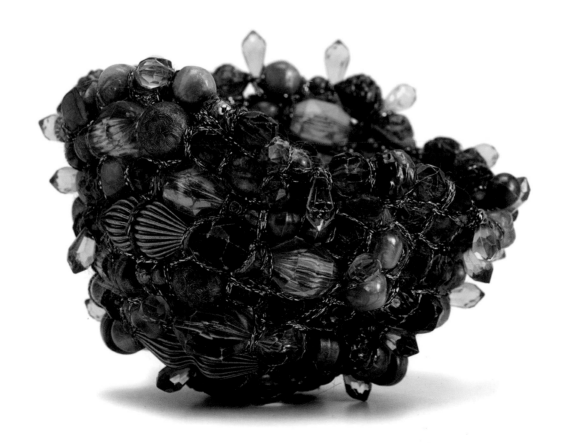

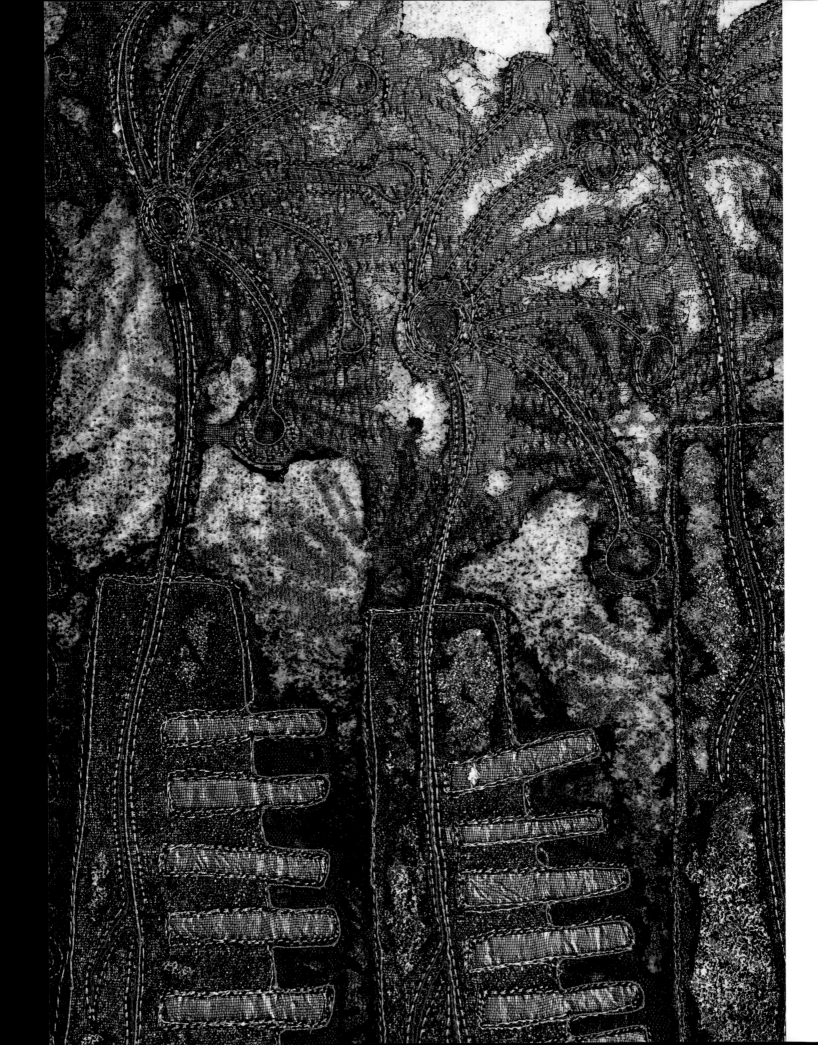

# Layered Textiles

New surfaces with heat tools, machine and hand stitch

Kim Thittichai

BATSFORD

*This book is dedicated to Eleanor Fielder, a colourful, vibrant student and friend. Without students like Eleanor teaching would be very dull!*

### Acknowledgments

Thanks to all the artists who allowed me to use their work in this book. Particular thanks to Kristy Richardson of Anova Books for her patience and care, and Michael Wicks for his wonderful photographs.

Very special thanks to my parents and my amazing sister – thank you.

First published in the United Kingdom in 2011 by
Batsford
10 Southcombe Street
London W14 0RA
An imprint of Anova Books Company Ltd

ISBN-13: 9781849940085

A CIP catalogue record for this book is available from the British Library.

20 19 18 17 16 15 14 13 12 11
10 9 8 7 6 5 4 3 2 1

Reproduction by Rival Colour Ltd, UK
Printed by Craft Print International Ltd, Singapore

This book can be ordered direct from the publisher at the website: www.anovabooks.com, or try your local bookshop.

Distributed in the United States and Canada by Sterling Publishing Co., 387 Park Avenue South, New York, NY 10016, USA

Page 1: Amber bead bowl by Kim Thittichai.

Page 2: *Buds in Bloom II* by Angie Hughes.

Right: Layers of gold satin and cotton velvet bonded together with painted Bondaweb and embellished with Xpandaprint, net, hand stitch, heat-transfer foils and beads.

# Contents

# Introduction

I love texture – looking at it, analysing it, creating it and, most importantly, appreciating it. While it is usually the case that 'less is more' there are times when more is much better. Layers of texture can be very exciting and just the thing to lift a flat piece of work – or the layers become the work itself. Whether your layers measure a few centimetres or several metres – be adventurous and experiment.

I first started thinking about layers at art college, where I studied wood, metal, ceramics and plastics. Some years later, when studying creative embroidery, I started to make three-dimensional sample vessels – this was before I was aware of the excellent heavy iron-on and sew-in interfacings that were available. Trying to make quilted forms stand up with just the aid of wire never did quite work out but I persevered.

At this time, the sculptor Hamish Black had an exhibition at the college entitled *Talking Books*. The sculptures were created from huge stacks of discarded books and telephone directories. Shapes were carved from the stacks of books to create the most amazing and exciting work. The scale and the content of this work have stayed with me, and no doubt informs my work now, as do many of the artists I have been lucky to work with and whose work continues to inspire.

No artist works in a vacuum and of course there are now many more exciting materials to work with. In my travels as a textile tutor I find there are still people who are overwhelmed with the choice of materials available to them, whether they are quilters, embroiderers or somewhere in between. I hope this book will make some of the available options a little clearer.

Any suggestions and theories mentioned in this book are purely my own and made in good faith; other tutors you work with may not agree with them but we all have our own ways. You need to decide for yourself what suits you. The only crucial piece of advice for using this book is to read it – and, on a practical front, when you start to work make sure you are in a well-ventilated room. Even if you are just sitting and stitching, have a good air flow; it keeps you more alert.

If you read this book through first you will get much more benefit than by just flicking through the pages. There is a good mixture of 'How to' projects and exercises, as well as finished pieces of work by students and professional artists that should spur you on to finish that masterpiece or even start a new one.

## Techniques, products and processes

My first book covered the basics for many of the techniques requiring heat tools. These will be explored further within these pages along with the introduction of many new products that have become available since writing *Hot Textiles*. So if you are interested in Vilene Spunbond, Hot Spots! and Lamifix then read on.

For those who are new to this kind of work and need help with the basic processes it can be very difficult to know just where to start; hopefully this book will help you on your way. For example, there is a section on how to apply heat transfer foils and how to decorate painted Bondaweb/Vliesofix. While using heat tools and synthetic fabrics are important parts of my work it is not all I do, so there are many ideas using paper and fabric covered in this book as well. All processes can be a surface on which you can stitch – you will just need to decide on the size of the needle and thread to use.

Layering processes, techniques and products can be very exciting but consider whether you need that extra layer of Tyvek or 3D medium/Xpandaprint. Ask yourself, Is it right for the piece? Will it distract or add to your work?

Words are very important to me – I find them an inspiration – so each section of this book is headed with a selection of words relating to the work in the section; use them to inspire, add to or even combine with your work. I hope this book will inspire you to develop new techniques, revisit some old favourites and maybe even look at the newspaper in the recycling bin with new eyes.

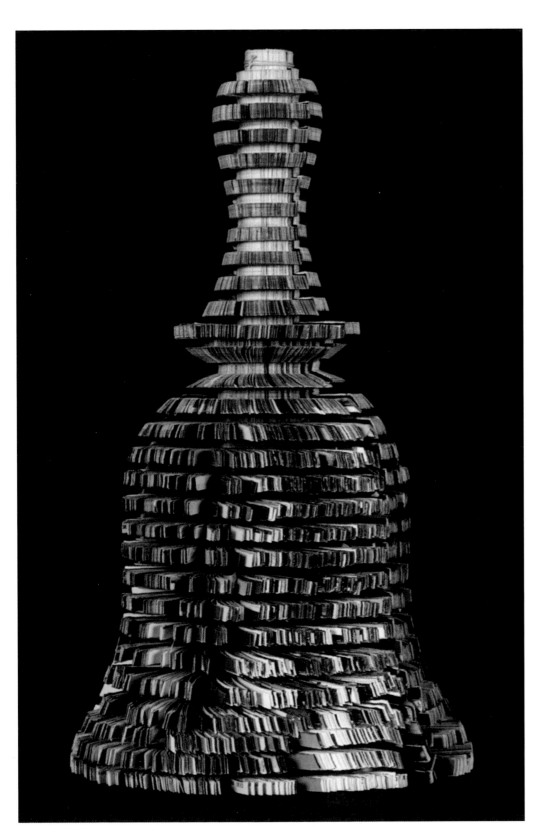

Left: Detail of *For Whom the Bell Tolls* (1997) by Hamish Black, made from paper and cut books.

# Inspiration

coating, blanket, coat, cover, covering, film, flap, floor, fold, laminate, layer, mantle, overlap, overlay, panel, pile, ply, row, seam, sheet, slab, stack, stratum, strip, stripe

You never know when inspiration will strike; it could be immediate or delayed. We store everything we see in our minds. It may be many years later that you see something that will start a chain of ideas and bring back something you first saw ten years ago. The brain is a remarkable tool.

Using layers was just the start of a very long inspirational journey for me. Being taught to 'see' rather than just 'look' was probably one of the most important things I learned. When you learn properly to examine how a leaf is joined to a stem, or work out how to recreate a particular colour you have seen, it will make a huge difference to the work you create for the rest of your life. Take the time when you are out and about to examine the simple things you find attractive. Whether it is the manhole cover in the pavement, a tiny shell on the beach or how the way-lines

of a landscape create beautiful shapes, all this information will inform everything you do and add new dimensions to your work.

As students at art college we were taught to understand the materials we were working with before we could design and complete a finished object. This was real 'designing through process'. We were taught to start with the basic techniques in wood, metal, ceramics and plastics and were then encouraged to work through all the different processes to create finished pieces. The way I was taught on that course is also the way I teach my own students. Working through the traditional techniques and then experimenting with each media meant I had total confidence in how I worked and the finishes I could use – I just had to learn to be inspired and how to use that inspiration.

This is not a tap you can turn on and off. Once you start down this route it will be a continuing process for the rest of your life. Many things will get in the way of your creativity but do persevere. Life's ups and downs and twists and turns will always tend to guide or obscure the joy we find in our work. But have faith; if you feed your inspiration whenever you can through looking, keeping notebooks and, above all, just relishing the sheer pleasure of something you delight in, the ideas will come. Whatever your age when you start your journey of creativity – you may be 18 and just starting college or 64 and trying a new workshop for the first time – hang on in there and just have fun.

There is a difference between creating work from an original idea and working from a kit or for a commission – creating work that changes as you add to it and designing something to be made as you have designed it is an organic process. While there is just as much validity in these ways of working, there is not much room to develop new ideas and discover new ways of working.

I teach processes in my workshops, not finished items. This can be a little uncomfortable for students who are used to completing a project, such as a box or a bag, in a workshop. I believe that if you teach basic techniques then the student can go away and make anything. It is all about making connections between your ideas and your materials and experimenting.

Whether layers are three-dimensional, a cross-section, flat, crusty or smooth there are so many amazing images to inspire us. Inspiration can be found all around. There are layers everywhere – running through the earth and in layers of clouds and colour in the sky. Look at the layers of a trifle, stacks of logs or chairs, peeling paint – the choice is endless. Many ideas can be interpreted into techniques and layered processes using the incredible array of materials now at hand. Think of what you find attractive and interesting about your stack or layer; can you describe the essence of what you see? If it helps, make a list of words that describe what you want to portray. Then think of the textures you can achieve with products and techniques available to you. Interpretation is always more successful than copying directly. How do you depict the things you like about your chosen layers?

Below: Inspiration can be found all around you.

# Basic Techniques

# Basic Techniques

It seems sensible to start with a look at the basic techniques that you will need to use when creating layered textiles. You can build on these with the range of materials and techniques that you will find described in detail throughout the rest of the book, as they are used for various practical projects.

I will start with Hot Spots! and printing on to foils, and using Bondaweb/Vliesofix. This introductory section will finish with a practical project – a layered flower sample – which will enable you to practise the basic techniques before going on to tackle more complicated projects.

## Heat-transfer foils and Hot Spots!

Transfer foils give a wonderful flash of shiny colour, but be warned – like many good things in life – a little goes a long way. Foils can be applied to fabric or paper and are useful for almost any craft project. When used with unpainted Bondaweb and Hot Spots! transfer foils are washable.

There are several types of heat-transfer foils, including Jones Tones and Tonertex, available in the UK, which are the best-quality foils to use in textiles. They are hot or cold release, are washable and don't fade – they never lose their flash. Omnicrom foils have escaped into the textile field from the printing industry. They are useful for many craft projects but are a different quality of foil and are not as reliable as Jones Tones or Tonertex.

Always use the foils colour side up. This is always confusing when you first use foils; the foil is released from the underside of a plastic carrier sheet.

Hot Spots! are spots of heat-activated glue that are similar to Bondaweb/Vliesofix. They can be used to bond fabrics and threads together and are particularly good for bonding the seams of stretch fabrics. More or less anything can be bonded to Hot Spots! but the larger the shape you apply to spots the more you lose its 'spottiness'.

Hot Spots! come in two sizes, small and medium. The clear spots of glue are on a firm brown paper background. This paper can be cut with scissors or a hole punch.

Hot Spots! can be used with an iron or a heat press. Whichever you use, always make sure you put baking parchment on the top of the Hot Spots! Never rely on just the brown paper or your iron will get into a terrible mess.

Hot Spots! are great for using up all those old sheets of heat-transfer foil and glitter that you may have, and are completely machine washable. They are really useful for decorating T-shirts, jeans and many other craft projects. They can be ironed on to anything flat that will take the heat of the iron, so they can also be used on wood, paper and card. When cutting out your design, make sure you cut the Hot Spots! paper away from your project on a different work surface. You might not notice if odd glue dots fall off the paper on to your project, which could contaminate your work later.

As with all heat-activated glue, when using Hot Spots! you need to wait for the glue to cool down before you remove the backing paper or baking parchment. Don't be tempted to apply all your decoration at once, but iron each one in place one product at a time. For example, apply the sequins first, then glitter and then heat-transfer foil.

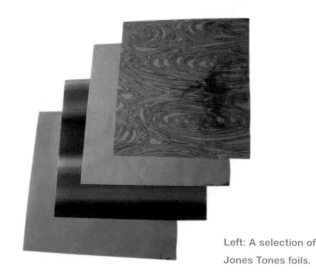

Left: A selection of Jones Tones foils.

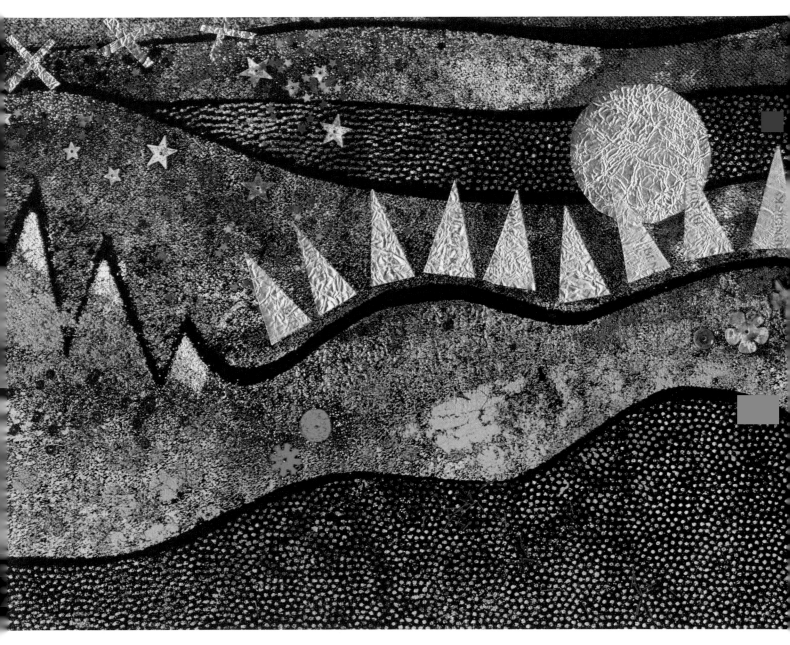

Above: *Sparkle Landscape*
by Angie Hughes, created by
combining foiled Bondaweb
and Hot Spots!

# Working with Hot Spots!

## You will need:

- Pencil
- Hot Spots! cut to your design
- Scissors
- T-shirt or project to iron on to
- Baking parchment
- Jones Tones heat-transfer foils
- Glitter, sequins
- Iron (steam turned off)

## Instructions:

1 Draw your design on to the brown paper side of the Hot Spots!

2 Cut your desired shape from the Hot Spots! Be careful to cut your shape out away from the area where you are going to apply the Hot Spots! If any odd spot of glue lands on the surface you are going to iron on to you may not see it until later, by which time it will be too late. Once these spots are ironed on they are fixed for good.

3 Lay your shape glue-side down on the surface on to which you are going to iron. Always use baking parchment under the piece of work you are ironing. Place a sheet of baking parchment over the top and press with a hot iron using firm, continuous pressure for a good minute. If you are ironing Hot Spots! on to a fine synthetic fabric such as polyester organza, you need to be careful not to melt the fabric. Do a test first if you are not sure.

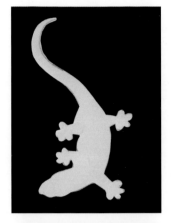

Stage 3

Stage 4

Stage 5

Stage 6

4   Wait for the brown paper to go cold and carefully peel it away from the spots of glue. You should have a complete shape in glue spots. If you peel off while the glue is still hot you will get a hit-and-miss effect that might look quite arty. It all depends on if you want a clear image or not. You now have your design exposed and ready to decorate.

5   Now you can have fun – decide what you want to decorate your spots with and in which order. If you are going to combine glitter with heat-transfer foil it is best to add the glitter first, than add the foil. When using foils you will need to turn the iron down to medium; if the heat is too hot the foil will pucker and the colour will not come off.

6   Lay your foil over the entire image colour-side up. Lay a sheet of baking parchment over the foil making sure you cover all of it. Iron with gentle pressure over the entire area for 30 seconds in a circular motion. Wait for the foil to cool right down and peel off from the Hot Spots! You should have a foiled image. Try the process over again with a different colour foil and see if the glue will pick up any more colour.

7   In the example shown left, small sequins were applied down the spine of the gecko and a large sequin was added to create his eye; baking parchment was laid over the whole design and ironed with a hot iron for 30 seconds, keeping the iron moving. Once the glue has cooled down the baking parchment was removed.

8   Glitter was then added down the centre of the design, and ironed off in the same way. All glitter was removed before applying foil.

9   Foil was laid over the sequins, glitter and exposed Hot Spots!, and baking parchment was placed over the whole design and ironed with a medium iron using gentle pressure for five to ten seconds.

10  Once the foil had cooled right down it was removed to reveal the colour.

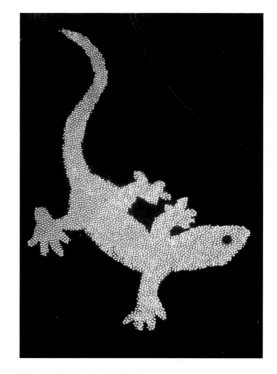

Above: Hot spots cut into a gecko shape, ironed on to a black T-shirt and foiled with silver heat-transfer foil.

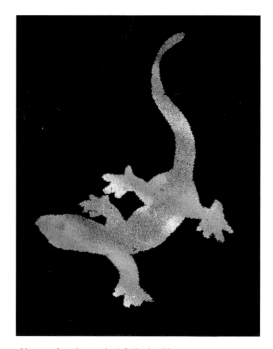

Above: As above, but foiled with a rainbow-effect heat-transfer foil.

# Applying foils to painted Bondaweb/Vliesofix

Bondaweb is one of the most useful products for any kind of textile project. Not only can it be used for appliqué but all kinds of decorative processes as well, only a few of which can be mentioned in this book for reasons of space. Just try putting 'painted Bondaweb' into your search engine – it is a remarkably versatile product.

When painting Bondaweb, use a simple water-based paint, because paints that have latex in them can cause problems with removing the backing paper from the Bondaweb. As a guide, you need to be able to see the backing paper through the paint. Bondaweb has a smooth backing paper; the glue is slightly rough to the touch and that is the side that you paint. If the paint is too thick it will form a barrier and the Bondaweb won't stick to what you are ironing on to. If using acrylic paints water them down by half.

**Right: Painted Bondaweb ironed on to black cotton and decorated with foils, sequins, zapped polyester organza and hand stitch.**

# Painted Bondaweb sample

## You will need:

- Bondaweb painted with water-based paints
- Background fabric
- Baking parchment
- Jones Tones heat-transfer foils
- Glitter, dried pressed flowers, skeleton leaves, whatever you have lurking in your workbox
- Iron

It is not necessary to apply all the suggested elements above. Indeed, painted Bondaweb can be beautiful with no extra embellishment.

Stage 1

## Instructions:

1 Cut your painted Bondaweb to the required shape. Place on to your background fabric, painted-side down. Cover with baking parchment. Press with a hot iron and gentle pressure for five to ten seconds. Wait for the Bondaweb to cool right down.

2 Remove the baking parchment and the backing paper to reveal the painted Bondaweb.

3 To foil the Bondaweb, lay foil over the Bondaweb colour-side up. Cover the foil with baking parchment. Using the side of the iron with the flat side facing away from your body, run the iron over the foil with a gentle pressure to create lines or slashes. If you can hold the iron at right angles to your work you will achieve a finer line of foil. A soldering iron can be used for more intricate designs but beware of tearing through the baking parchment and foil. Work slowly if using a soldering iron as it has a fine point of heat and it will take longer for the heat to travel through the baking parchment and foil. If you have a Clover iron, which is a very small iron on the end of a soldering iron handle with a thermostatic control, you could use that. Leave to cool then remove baking parchment and foil.

4 If you wish to add glitter then sprinkle a small amount on to the Bondaweb and iron on using baking parchment. Leave to cool before removing the baking parchment.

Stage 3

The sample shown below has artichoke heart seeds added, but you could apply sequins, dried pressed flowers, skeleton leaves, indeed anything that is dry and flat.

Do bear in mind when layering up your textures that you don't have to add everything in your workbox. The wonderful (and dangerous) thing about Bondaweb is that you can keep reheating it and applying more decoration. It is important to know when to stop. You usually realize you should have stopped the layer before the one you have just finished. But judgments like that come with experience.

While you are learning new techniques it is obviously fun to try everything you can lay your hands on. Once you have mastered this technique try keeping the colours you use to tones of one or two colours. I have found that it is best to either have a lot of texture in your work or a lot of colour. Too much of either can be very distracting to the viewer. Bondaweb can be ironed on to wood, paper and card as well as fabric.

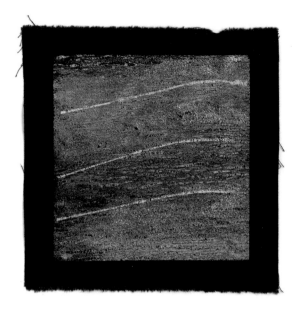

Stage 4

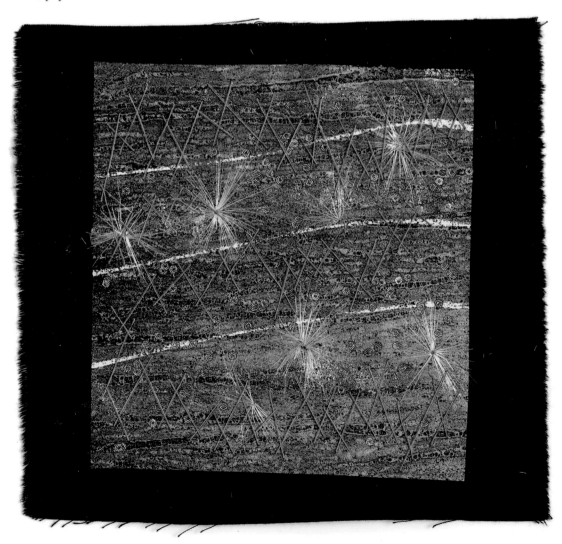

Left: Painted bondaweb decorated with heat-transfer foil, glitter, artichoke heart seeds and hand stitch.

# Printing on to foils

Foiled Bondaweb and Hot Spots! make an eye-catching surface on which to print. Using foil as a background to print on to may seem a little flashy, but you may be pleasantly surprised by the effect. The shine can be knocked back very successfully by the application of a matt printing media such as acrylic paint or fabric paint. Although the surface of the foil is very smooth and shiny it will take many types of printing media. However, because of the composition, most sprays are too thin and won't stick to the foil's surface. For a more textured print you could try adding dye powders to texture gels (always wear a mask when using powders). With this process you can control the colours you use and print with a very heavy texture gel, which will leave a fabulous translucent print. Even when printing with heavy texture gels and mediums your fabric should still be pliable enough to stitch into.

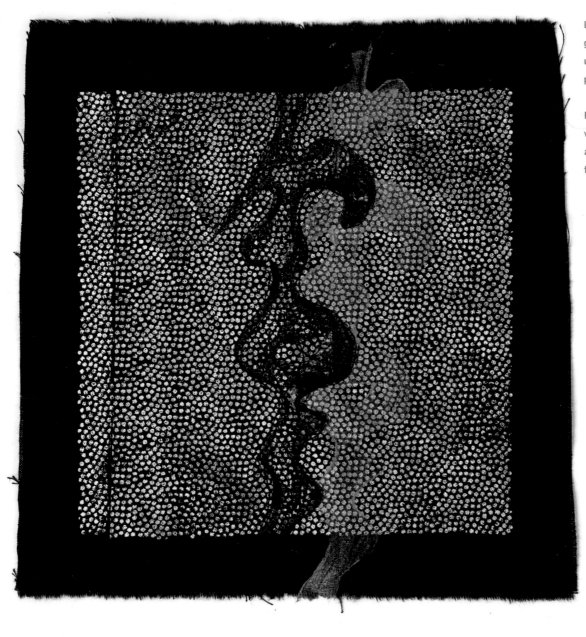

Left: Hot Spots! foiled with gold heat-transfer foil and used as a background for printing.

Right: Bondaweb foiled with gold heat-transfer foil and used as a background for printing.

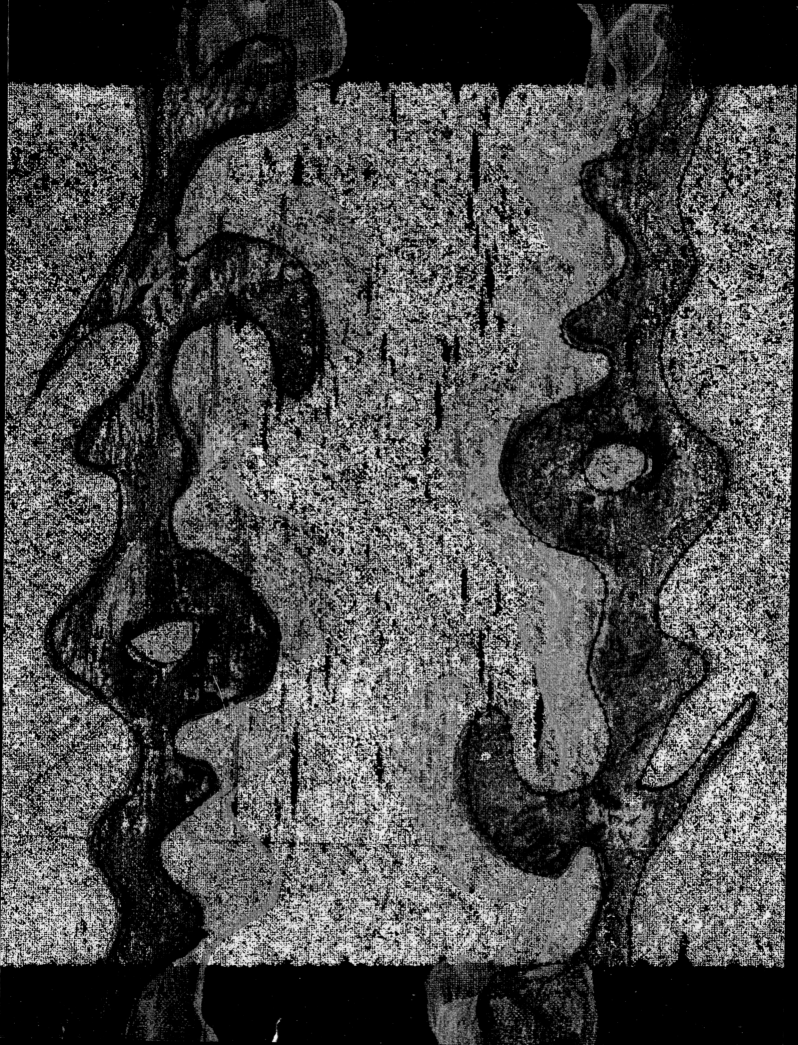

# Layered flower sample
## by Sarah Lawrence

## You will need:

- Chinese paper money or josh papers. These have interesting typography and are gilded. Alternatively gild your own background papers
- Scissors
- A craft sheet (non-stick to work on)
- Several sheets of 'repair tissue' or thin bookbinders' tissue (thin abaca)
- Watered-down acrylic medium or a thin clear-drying glue and brush to spread it with
- Some gilding flake in a colour of your choice
- A selection of cut or punched paper shapes (not too large)
- Selection of crayons, oil sticks or paint
- Baby oil and soft cotton wool
- Water-soluble film (Romeo) and a selection of machine threads
- Sewing machine

## Instructions:

1  Lay out your paper money or josh paper face-up on to your craft sheet background.

2  Cut your repair tissue a little larger than the background paper. Glue this on to the background paper. Scrunch the surface a little to add textual interest.

3  While the layers are wet with glue, sprinkle gilding flake and cut paper shapes on to the surface. If there is a bold area of gilding you may choose to leave that area unadorned.

4  Place the second layer of repair tissue on top and, if necessary, brush glue over the top to secure the bond. Again, manipulate the surface to give a wrinkled texture. Allow to dry.

5  When dry, colour the surface with either crayon or oil sticks or paint. Each medium will give a different effect and they can of course be combined. If appropriate, allow to dry.

Stage 3

Stage 7

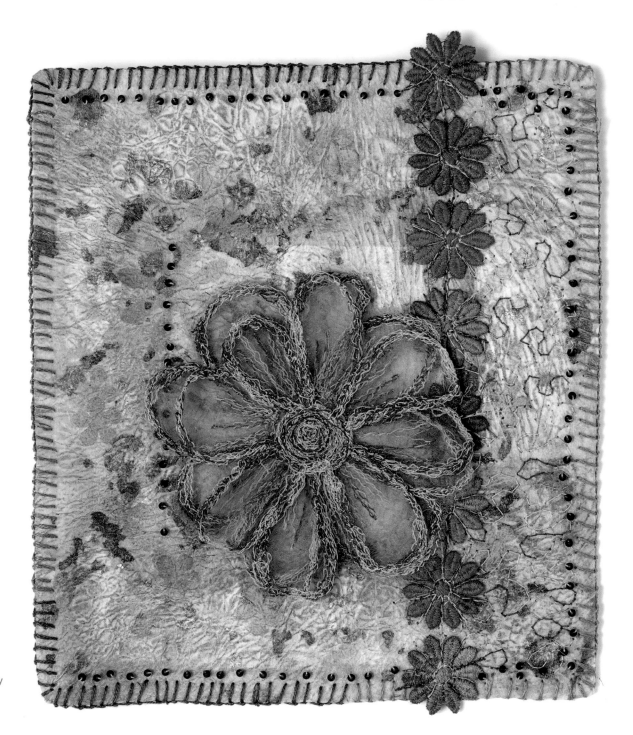

Right: The finished layers of decorated papers, paper shapes and free machine embroidery embellishment.

6 Using the cotton wool ball or pad, apply a small amount of baby oil to the dry surface. (If you isolate any gilded areas they will 'pop' out and shine.) The oil seeps through the papers and gives a translucent effect.

7 Leave at least 30 minutes before you stitch into the surface. Stitching can be done by hand or by machine (or a combination).

8 Separate elements can be created using water-soluble film and free machining. Water-soluble film is a product that is stretched in an embroidery frame as a base for free machine embroidery and is then washed away leaving your stitched work. There are different brands and types; some look like clear plastic while others look like fabric. These can be applied when dissolved out and dried on to the decorative layered backgrounds.

9 Edges can be stitched down or folded and glued or simply left with an 'unfinished' appearance. It is up to you.

Layering
Colour

# Layering colour

blush, colouring, complexion, dye, glow, hue, intensity, iridescence, luminosity, paint, pigmentation, saturation, stain, tinge, tint, undertone, value, wash

**Colour:** refers to the wavelength composition of light.

**Shade:** a gradation of colour referring to its degree of darkness.

**Tint:** a gradation referring to its degree of lightness.

**Hue:** indicates a modification of a basic colour.

Colour is the most powerful tool we have to work with. Used well and with confidence colour can make your work sing. Too many colours in a piece of work can make it very complicated to look at and confuse the brain so if you are not sure about which colours to use, good advice is always to keep it simple. If you don't already, start collecting ideas and interesting colour combinations and keep them in a scrapbook or sketchbook so you can refer to them easily when you are working on your next project.

Don't be afraid of collecting and storing information. By doing this you are creating a tool that will help you make decisions and inspire you at a later date. There are sources of colour everywhere: magazines, photographs, gardens, fabrics, threads…

With the advent of high-quality cameras on mobile phones it is very easy to snap a quick image to remind you of a particular colour combination when you are out and about. Just remember, if you are thinking of taking a photograph of someone else's work, ask their permission first.

Right: Layers of natural fabrics pieced together create a background to print on to in white. The whole piece was then painted with procion dyes. Hand stitch was used to highlight areas using hand-dyed threads.

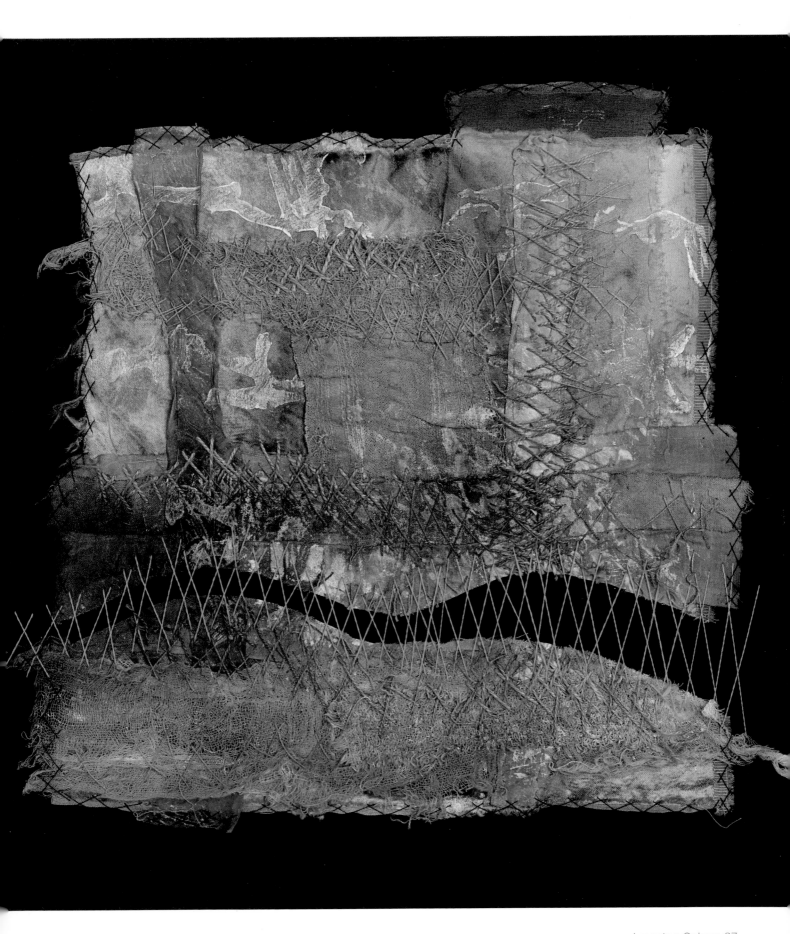

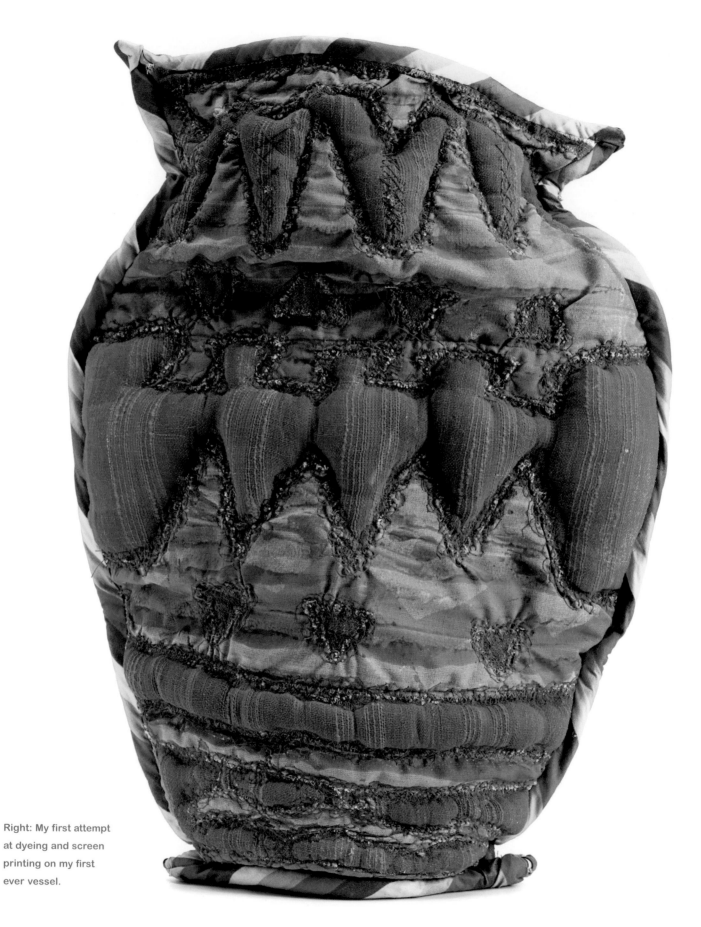

Right: My first attempt at dyeing and screen printing on my first ever vessel.

# Colouring your fabric

There are many ways of applying colour to fabric depending on what the fabric is made from. All of the dyes mentioned in this chapter can be thickened and used for printing.

## Dyes for natural fabrics

Natural fabrics made from cellulose fibres such as cotton, linen and viscose can be dyed with fibre-reactive dyes, also known as Procion MX dyes. These dyes can also be used for dyeing silk but silk is usually dyed with acid dyes (see below). Soda ash is used to set these dyes.

Fabric coloured with fibre-reactive dyes will not bleed in washing or fade, unless exposed to bright light. This makes these dyes popular for tie-dyeing and batik, which often feature brightly coloured patterns. Fibre-reactive dyes can be painted on or dip dyed. The book I use for reference on this subject is *Colour on Cloth* by Ruth Issett (see Further Reading, page 124).

Procion dyes come in powder form so care must be taken not to ingest them. A particle mask and gloves are essential when handling any of the dyes listed in this section. Once mixed with salt and soda ash the dyes are at full strength for about two hours, and then they start to deteriorate. Spent dye can be used to colour paper and card to great effect. Always carefully follow the instructions on the dye packet.

Acid dyes are best used for painting or dyeing silk fabrics as well as dyeing protein fibres such as wool, camel, fur, feathers, cashmere and some synthetics such as nylon. The dyes are set using distilled vinegar in a hot dye bath or with the heat from steam or an iron. These dyes give a brighter colour with silk than Procion MX fibre-reactive dyes.

Natural dyes give subtle and varied results depending on the method used to extract the colour. Using a mordant will help to make the colour 'stick' and improve colour fastness. Most natural dyes come from dye plants, the best known of which include madder, Brazil wood, logwood, weld, woad and indigo. Some natural dyes, such as cochineal, come from insects, and others come from mineral sources. Madder, weld and other dye plants have been used for thousands of years. Until the late 1800s, when synthetic dyes came into common use, natural products were the only source of dyes. As long as alum is used as a mordant, plant dyes use no toxic or polluting chemicals, and the organic matter left over from dye plants can be put on the compost.

## Dyes for synthetic fabrics

Disperse dyes were developed in the early 1920s to dye the new synthetic fabrics that would not colour with established dyes. Using disperse dyes meant that the new fabrics could be dyed with colourfast colour without the use of water. Disperse dyes have been developed in powder and liquid forms and are also used in crayons. There are many synthetic fabrics available, from satin and chiffon to felt and velvet. Nylon, acetate and polyester are the most well known. They all take disperse dyes extremely well.

Work with a pale coloured or white fabric for the brightest colours. The dyes become fast when heated to 90–100°C (194–212°F). They can be applied to fabric in several ways, such as immersion dying in a saucepan on the hob and space dying in the microwave, but one of the most popular is transfer printing. Disperse dyes are transparent and can create amazing layered effects.

**Working safely:**

- When using dye powders always wear a particle mask. Avoid draughts and cover your work surface with damp newspaper to prevent powders drifting on a breeze.
- Protect your hands with rubber or latex gloves. Both types are available from your supermarket or local DIY store. If you do get any dye on your skin, wash it off immediately with plenty of soap and water.
- Never use the same utensils and work surfaces for dyeing that are used for food and drink preparation.
- Leftover dye mixture can be stored in an airtight container. Label the container and store away from foodstuffs.

# Transfer printing with disperse dyes

Use the disperse dyes in the same way as you would paint. They can be thinned down to create more pastel shades and can be thickened to print with. The colours will look rather dull and uninspiring when you paint them on to your paper, but prepare to be amazed, as they become quite vibrant when transferred to synthetic fabric. If you find the colours a little too bright, try transferring on to a natural fabric. The colours will be more muted.

Disperse dyes work particularly well on sew-in interfacings, Vilene Spunbond and white or cream acetate or polyester satin. Following the manufacturer's instructions, the powdered dye is mixed with water and then painted on to smooth paper (photocopy paper is perfect). Once the paint is dry the design can be ironed off, painted-side down, on to your fabric of choice. The iron needs to be as hot as the fabric you are ironing on to can stand. Always use baking parchment to protect your ironing surface, and between your iron and your work, and iron for at least one minute; if you are lucky to own a heat press, this will give the most amazing bright colours. These paints are permanent once they have been ironed on to synthetic fabrics.

When you have successfully transfer printed on to fabric, try printing on to clear polythene bags. Acetate sheets that are used to photocopy on to will also take a transfer print. Bear in mind, though, that the iron needs to be on a medium heat when printing on to plastics, as there is a fine line between transferring your design and melting the plastic entirely.

Resists or masks can be used between the transfer paper and your fabric. Try using dry grasses and seeds or a paper doily. The most important thing to remember is to keep the iron moving as you work. Transferring the design can take several minutes with a hot iron and if you don't keep the iron moving you will end up with a print with the shape of the iron on it. Try not to move the paper as you iron or you will get a shadowed print. When working with fine fabrics such as polyester organza beware of melting the fabric on to the paper. You will find most painted papers can be used two or three times, but they get paler every time you use them.

Transfer paints can be applied to the paper just like any other paint so try using rubber stamps and printing blocks as well. If you find the paint a bit thin when using your printing blocks you can add a thickener. Always remember that your designs will be reversed when ironed off.

As you are printing on to synthetic fabric, once you have transferred your design, try heat gunning your fabric and distressing your work. If you have a soldering iron you can iron some Bondaweb on to the back of your newly dyed/transferred printed fabric. Then cut out intricate shapes with a fine-tipped soldering iron and iron the shapes on to a suitable background fabric.

# Printing and painting

Dyes are permanent and can be washed but if your work is not going to be washed then you can paint or print with any colouring medium you prefer. I tend to use basic acrylic paint for printing but there are an amazing amount of different paints and sprays available. For example, the sprays with mica in them are particularly effective and layer up beautifully on Vilene Spunbond and Tyvek. When colouring your fabrics do consider whether you will be using heat tools during the construction of your project. If you want to distress your fabric using a heat gun do not use any oil-based products on your fabrics as these will give off fumes when you heat them. Always spray your work well away from other people, preferably outside in the open air and definitely not in the same room, as you cannot know what might affect other people adversely. Be particularly careful with aerosols, especially products such as varnishes and hairsprays, used for sealing pieces of work.

Right: Transfer-printed polyester satin with Bondaweb ironed to the back then cut with a laser cutter. Once cut, the backing paper was removed and the shapes were ironed on to the surface of the design.

# Lee Brown

Lee Brown is a very popular textile artist and tutor, whose work has been exhibited in several private collections and internationally, winning many awards.

*Hot Flush* (see right) is Lee's textile interpretation and reaction to the menopause. Lee started with all white and cream fabrics, applying different weights of silk and satin to a calico background. These were overprinted with black acrylic paint using printing blocks that Lee had made from one of her drawings of church windows. She then dyed and overdyed by painting on Procion fibre-reactive dyes. The piece was then backed with black calico and machine stitched. In some areas an Italian corded technique was used to give extra lift. Lee also applied very small areas of heat-transfer foil. To use any more of the foil would have been distracting.

Lee's lifelong interest has been trying to create a visual three-dimensional effect in a two-dimensional media. Lee creates remarkable quilts, many of which depict ancient buildings that you feel you can walk right into.

The source for *Byzantine* (see left) was a photograph Lee had taken of a tiled floor in a church. The more Lee looked at the floor the more the marble tiles seemed to rise away from the background grid of tiles. This intrigued her, so Lee took a photograph, committed the floor to memory and when the time was right worked from her impressions, backed up by the photograph. Lee did not want to reproduce the floor; she wanted to interpret the image it had generated.

The background grid is machine-pieced calico and silk. The raised marble tiles are individually made from dyed calico and moulded over thick, sew-in interfacing. The final embellishment is stitched using Indian floss and machine satin stitch. The black shadows on the tiles are black cotton organdie.

Left: *Byzantine* by Lee Brown.

Right: *Hot Flush* by Lee Brown.

# Working with silk tops

One satisfying way of working with colour is building up layers of wool or silk tops to create a wonderful depth. It is possible to keep adding your fibres to build up quite a thick layer of colour. It is also a great way to mix and blend different colours.

I tend to use mulberry silk tops as the fibres have a beautiful lustre. I dye my silk fibres and threads with Procion dye powders, but you can also use acid dyes.

I do my dyeing using a plastic bag method, which enables me to dye as much or as little as I like of each colour. I sort the damp fibres and threads into large, clear plastic zip-lock food bags and stand them in trays. I then make up my six basic dye colours – lemon yellow, golden yellow, magenta, scarlet, turquoise and ultramarine. As you add different colours to the bags you can see the colours mixing and you can happily mix up colours as you go. I love the way these dyes mix so well, and how the colours are so clear. The bags of fibre and dye are then left overnight and thoroughly rinsed and dried the next day. It never ceases to amaze me how luminous these silk fibres are.

I also use the dye to colour the background to which I am going to apply the silk fibre. A heavy iron-on interfacing is my usual background of choice. In the case of *Twilight* (see right) I colour-washed the glue side of the product in tones of turquoise and purple. Once it was dry, I started to lay on the silk tops using long lengths of the fibre to create loose 'stripes'. As the silk fibres are so fine, it is a good idea to work on a coloured background as you will be able to see through the fibres. Once I have built up a good basic layout I lay baking parchment over the whole piece and iron the fibre in place. I then carry on applying fibres and ironing them on until I am happy with the depth of colour and the shapes that have been created. To add extra interest I add large strips of painted Bondaweb as a final layer. The piece is then cut to shape and applied to a canvas. The whole surface is then coated with several layers of acrylic wax to protect it.

As this is an 'iron-on' process, the finished result can sometimes be a bit flat, so textural mediums such as Xpandaprint, texture gels or embossing powders can be added to lift the surface, but these products should be used sparingly as a little goes a long way.

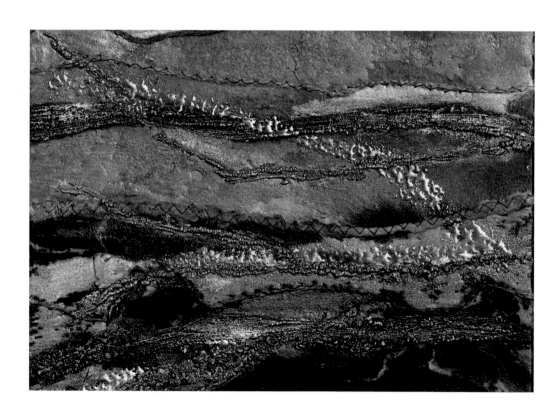

Left: Detail of the embossing powders and Xpandaprint used in *Twilight*.

Above: *Twilight* by
Kim Thittichai.

# Clare Rose

Clare Rose is a jeweller-turned-feltmaker and now creates beautiful and often humorous pictures from wool tops (carded wool). Clare pre-felts her backgrounds and then applies small lengths of wool fibre with a felting needle to create the image. Her work has a painterly feel to it as she blends and builds the layers of wool tops.

There are various techniques for making felt but, in very general terms, you simply need friction to 'felt' the fibres together.

To make felt, lay a towel on your work surface and lay an old bamboo blind or some bubble wrap on top – basically something flat that has texture. Then lay down an old nylon net curtain. On to this start to lay out thin sections of wool tops. Build a layer, overlapping as you go, till you reached a thickness of about 25cm (1in). Lay another piece of nylon net curtain over the top of your wool.

Make up a mixture of soap flakes and hand-hot water and sprinkle over the layers of net curtain and wool. Scrunch a plastic carrier bag or piece of bubble wrap into a ball that will fit in your hand and start to rub over the surface of your layers with continuous and firm pressure.

Your work will start to felt together quite quickly. Keep adding the warm soap mixture and turn the work over regularly so that is felts equally.

For more information on making your own felt, see Further Reading (page 124).

**Right:** *Poppy Field* by
**Clare Rose.**

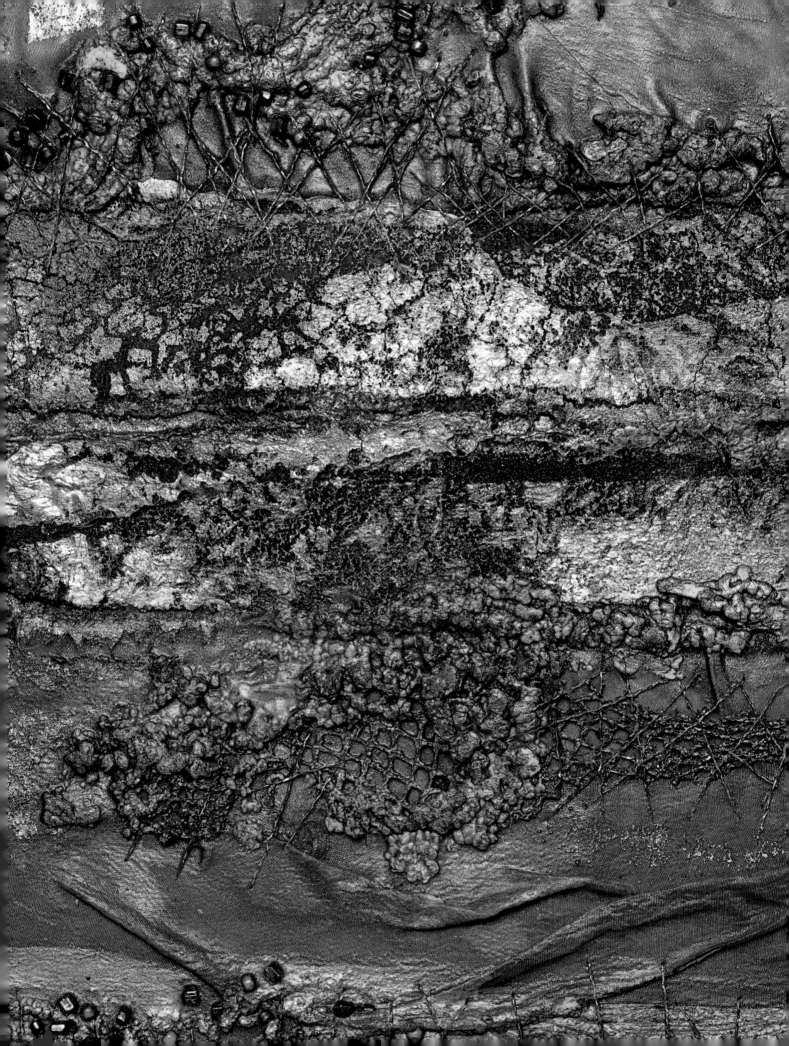

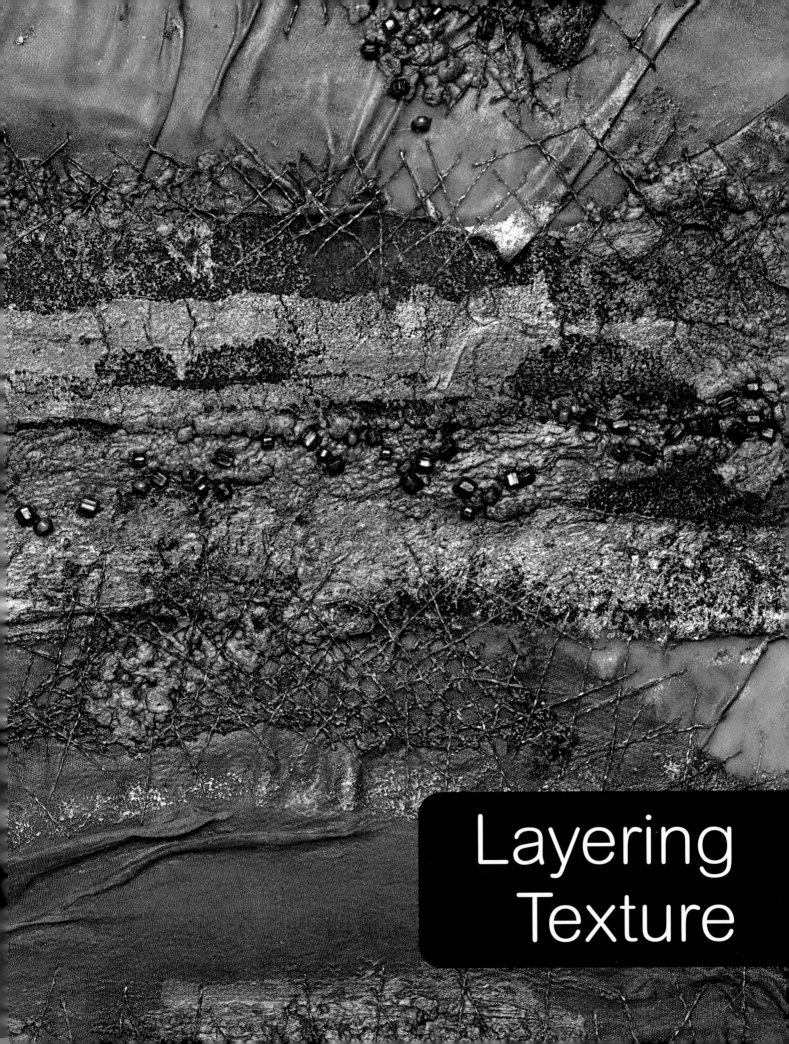

Layering
Texture

# Layering Texture

fabric, feel, fibre, fineness, flexibility, form, grain, nap, nature, pattern, quality, roughness, sense, smoothness, stiffness, structure, surface, touch, warp, weave, web, woof

After colour, texture is one of the most important ways to make your work interesting and intriguing. Anyone who has exhibited their work will know how difficult it can be to stop visitors from touching it. Texture is very exciting and one is always drawn to find out 'how' and 'why' it has been created. Used with a heavy hand, however, texture can ruin your work.

There are many processes and techniques that can raise the surface and, used with care and sometimes camouflage, they can be very successful.

Xpandaprint is a paste that can be printed and painted on to your work, then puffed up with a heat gun. A small amount goes a long way: if applied too thickly it can form into balls and fall off your work. A thin layer can be applied with a paintbrush or it can be printed on with a printing block. Once you have expanded it with a heat gun I recommend that you colour it with various tones of one colour. Blend it into your background.

A word of warning when using a heat gun on your work – if you are stitching with plastic-based threads there is a danger they will melt with the heat from the gun. Amazing textures can be created with the aid of a heat gun, but you will need synthetic fabrics for these techniques. Most synthetic fabrics can be distressed with a heat gun unless it has been flame guarded. When working with heat guns always make sure you are working in a well-ventilated room and never use oil-based paints to paint your products, as these can give off fumes. Try to use a water-based colouring media instead.

Just by intentionally adding creases you can add another dimension to your work. I never iron my fabric before I start work but I know a lot of artists do. We are trained at school to be neat and organized when we work, and this can stay with us into our adult lives. Anyone looking in my studio will see how this training has passed me by; I work best surrounded by mess. Try creasing up your layers before you apply them; you may get some surprising results.

Right: *Red Strata* by Kim Thittichai. Painted Bondaweb ironed onto brown acrylic felt and decorated with hand stitch, Xpandaprint and heat transfer foils. Sealed with acrylic wax.

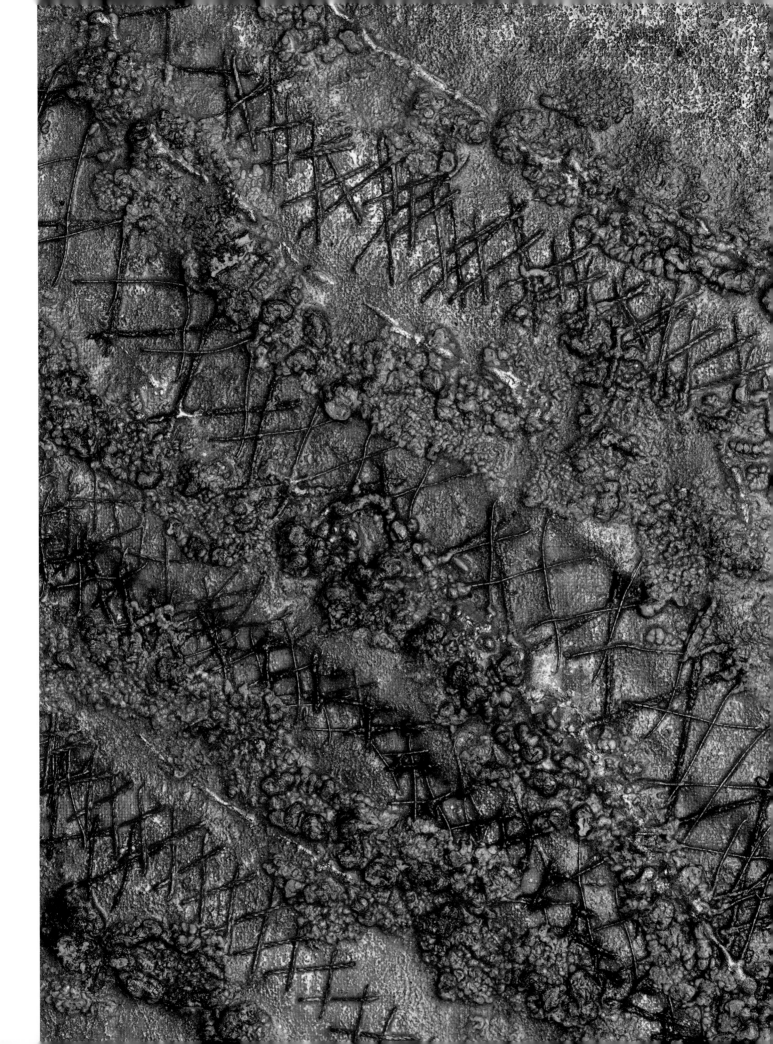

# Working with Tyvek

One of my favourite products to use with a heat gun is Tyvek. Tyvek is a spunbonded, paper-like fabric made from very fine, high-density polyethylene fibres. It is rip-proof and waterproof.

Heavier weight Tyvek is used in the building trade and the more drapeable fabric type is used, among other things, to make scene-of-crime suits. Tyvek can be painted with any water-based paint. Mica sprays are particularly successful as they don't build up a thick layer, which can then prevent the heat from melting the Tyvek.

If you wish to use paints you will probably need to water them down. Tyvek needs to be painted in the same way as Bondaweb (see page 16); you need to be able to see through the paint. Thick acrylic paint and paints with latex in them will stop the Tyvek from melting and distressing.

For the best effect, layer and stitch sheets of heavier Tyvek together. You can choose to layer on to a background or not. Your background would need to be a product that does not melt with the heat gun. For example, I use a heavy sew-in interfacing painted in a contrasting colour. Machine stitch through all the layers in a basic, clear design and then zap with a heat gun. Try to reveal different layers as you work. It is a great lesson in control. Always use your heat gun straight up, not at an angle and make sure it is at least 2.5cm (1in) away from the surface of your work. Raise and lower the heat gun as you work to expose different layers of colour.

## A Tyvek sample

### You will need:

- 5 sheets of A4 Tyvek painted on both sides in contrasting colours

- Sewing machine

- A4 piece of heavy sew-in interfacing

- Heat gun

### Instructions:

1 Layer your sheets of Tyvek and stitch together securely with a sewing machine. It is always more interesting to stitch a design to hold your work together than to just 'take a line for a walk'. The design can be quite basic and you can draw on to your Tyvek if you need to.

2 Zap your sample with a heat gun to create texture and reveal different layers of colour. To add extra interest you could add polyester organza between the layers of Tyvek. Polyester organza is much finer than Tyvek and will therefore melt much faster but it gives a wonderful crunchy effect around the area you have distressed.

Left: Three layers of 75gm Tyvek with layers of polyester organza between layers. The fabrics were machine stitched together in a spiral design, then zapped with a heat gun to reveal different layers.

## Working with Vilene Spunbond

Vilene Spunbond can be bought in white and in three different weights. CS500 is the finest, CS700 is medium weight and CS800 is the heaviest. The fine CS500 can be bought in seven different colours and there is also a creased or 'crashed' version. The medium weight CS700 can also be used as a firm but not too heavy background when using an embellishing machine.

All weights can be distressed with a heat gun, cut with a soldering iron and transfer printed very successfully. Out of all the products I have tried Vilene Spunbond is the best I have found for creating a distressed texture with a heat gun.

It is possible to create exquisitely fine work with the finest Vilene Spunbond. Soft, fairy-like effects belie the strength of this very smart material. As you start to layer any of the weights the Vilene Spunbond becomes firmer and all kinds of three-dimensional projects then become possible. The heavier weight CS800 is my favourite, however, as I specialize in large three-dimensional textile forms.

Vilene Spunbond will take most types of colouring media but I think the most effective ones are the mica sprays, as the threads in the Vilene Spunbond pick up the metallic micas and subtly catch the light.

# A Spunbond sample

## You will need:

- Sewing machine
- A4 piece of heavy sew-in interfacing painted or sprayed a colour of your choice
- Two A4 pieces of Vilene Spunbond CS800 painted or sprayed
- Two A4 pieces of Vilene Spunbond CS700 painted or sprayed
- Two A4 pieces of Vilene Spunbond CS500 painted or sprayed

## Instructions:

1 With the interfacing on the bottom, layer the Vilene Spunbond by weight with the CS800 next to the interfacing, then the CS700 and then the CS500. If you layer with the heavier Spunbond on the top, when you start to distress the layers, by the time you have distressed the heavy top layer all the thinner layers underneath will have melted too. Machine stitch all the layers together.

2 Zap your sample with a heat gun to reveal different layers as you distress the work.

3 As with layering up Tyvek, you can introduce polyester organza in between the layers of the Spunbond. Try layering different weights of Spunbond and Tyvek together. If you wish for a more distressed effect you can leave out the background and have a much more disintegrated effect by melting through all the layers.

Above left and right: Four layers of Vilene Spunbond layered on to dyed sew-in interfacing (craft Vilene). The sample was machine stitched with a simple design and zapped with a heat gun to reveal different layers of colour.

# Creating textured layers
# with paper and Bondaweb

Paper is a very versatile medium, which can be torn, cut, punched, curled, distressed, pulped, stitched and stuck together. Papers can be dyed, sprayed, painted and printed. Handmade papers are especially exciting to work with. Working with paper seems somehow to be less worrying than working with fabric; I always feel I can be more adventurous with paper – after all, it is only paper.

I start with a background of firm handmade paper (rag is a favourite). I then apply long, torn strips of painted Bondaweb in a toning colour, usually a shade or two darker than the background (don't forget to use your baking parchment, see page 14).

I then apply torn strips of other papers I have lurking around on to the Bondaweb. This is then torn into strips and the strips are bonded on to another background. This step is repeated until I reach my desired thickness. Working in this way creates the amazing textures and because you are tearing the paper you will have a lovely, uncontrolled look to your work. More textures can be added by carefully applying Xpandaprint and hand stitching.

This process is a great way to use all the old papers you have stacked in a corner of your workroom that you have earmarked to use 'one day'. If you are anything like most textile artists I know, myself included, you will have a collection of wonderful scraps of coloured papers, old painted newspapers, dyed lining paper and rolls of handmade paper that look too beautiful to use. Tear them up and create something fantastic. The thick textures you create will make amazing book covers, vessels and boxes.

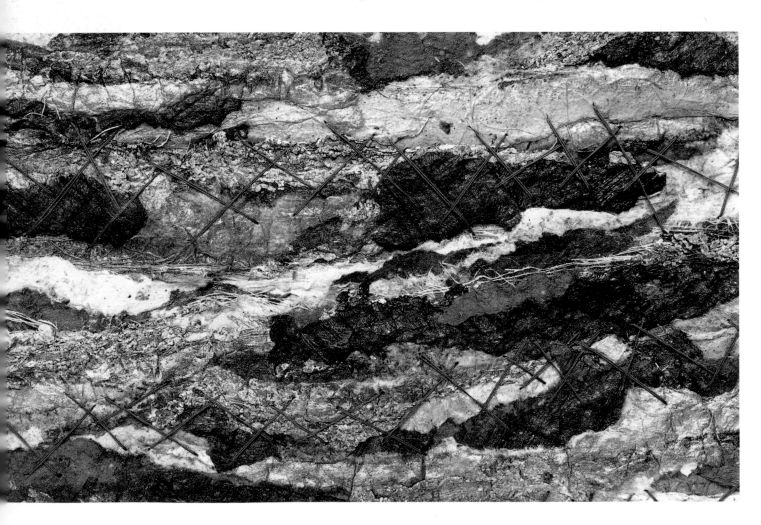

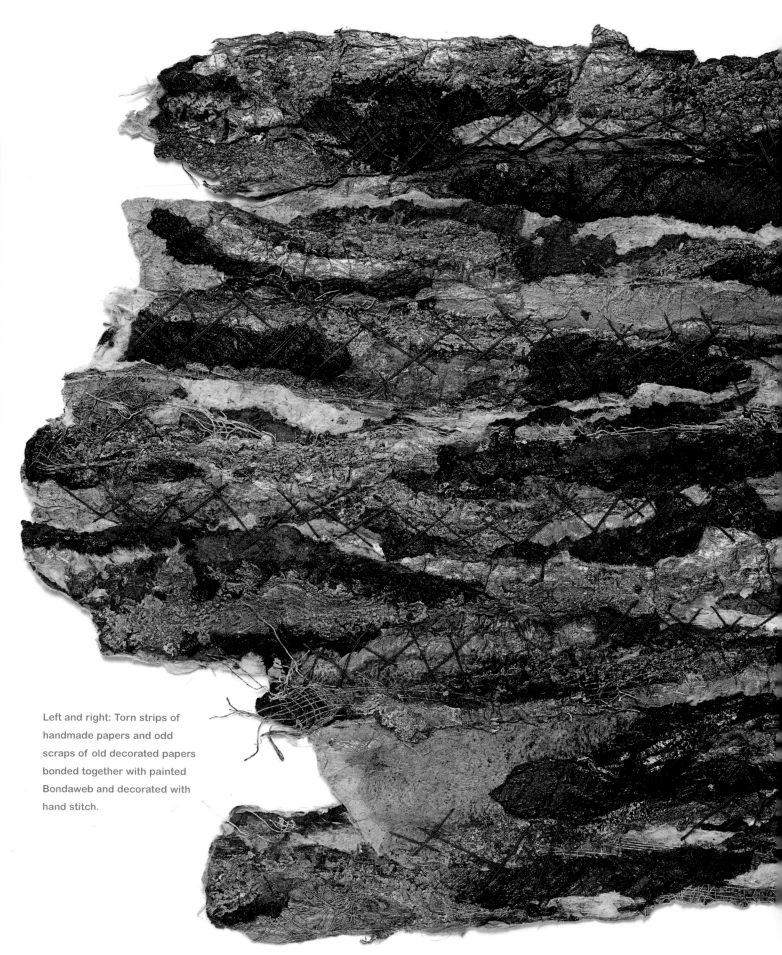

Left and right: Torn strips of handmade papers and odd scraps of old decorated papers bonded together with painted Bondaweb and decorated with hand stitch.

# Working with Solufleece/Soluvlies 321

An exciting way to create a creased or smocked effect is to use Soluvlies 321.

Soluvlies 321 is a water-soluble machine-embroidery product and is ideal for open or delicate work; it is also durable enough to withstand heavy needling. It is a good stabilizer for all types of fabrics and washes away in cold water (or, for faster removal, warm water) without leaving any residue. It can also pucker when steamed to create a faux smocked effect. This textured effect can be used as a panel in a bag or the centre panel of a corset or a cushion. The process is called 'crashing'.

## 'Crashing' with Soluvlies 321

### You will need:

- Scissors

- A fine- to medium-weight top fabric

- Soluvlies 321

- Bondaweb

- Sewing machine

### Instructions:

1 Cut one piece of Soluvlies 321, one piece of top fabric and two pieces of Bondaweb to the same size. Remove the backing paper from the Bondaweb carefully.

2 Layer, with the Soluvlies 321 at the bottom, the pieces of Bondaweb in the middle and your fabric on the top. Do not iron together, tempting though it might be.

3 Stitch parallel lines into the layers using your machine foot as the width guide.

4 Using a steam iron, steam your work by hovering the iron over your work (do not let the iron touch the sample) and be amazed how your work shrinks and puckers.

Stage 3

Stage 4

## Using 'wet' textures

You can buy some amazing gels and mediums, clear gels, coloured gels, gel with mica and pumice and even semi-precious jewel dust. They can be applied with printing blocks, brushes or your fingers, whichever implement will give you the desired result.

# Isobel Hall

Isobel Hall is a teacher and textile designer who specializes in creating handmade paper and using it to make embroidered bags. She teaches paper-making, book-making and bag-making and also takes on commissions. Isobel is well known for her exquisite, yet fully functional embroidered bags, made from handmade paper and embellished with print, stitch and beading. She is also an internationally renowned author and textile artist. Isobel works with fabrics she has made from scratch and makes her own pulp papers and silk papers. She likes to explore new techniques using innovative products to create unusual designs, texture and creative embellishments, and she has become well known for her work with waxes on papers and fabrics. The articles she subsequently makes from her fabrics are all road tested to ensure that they are robust and fit for purpose. Her bags, books, jewellery and vessels are all intended to be used and are not meant to be 'wall art', although they sometimes end up being so.

Right: Detail of *Bronze Vessel* by Isobel Hall.

# Reusing waxed papers

To clean an encaustic iron when you are changing colours you can iron on to kitchen paper towels. Alternatively if you have textured kozo paper you can iron on both sides of the paper. You will end up with a muddy collection of colours, usually including gold, silver or bronze. When this paper has been waxed in this way on both sides you can use it for other techniques.

Isobel is often asked during workshops what to do with the leftover sheets of paper on which she cleans her encaustic iron. This is one of her techniques:

**You will need:**

- Golden light moulding paste
- Baking Teflon (baking parchment will cause ripples)
- Textured kozo paper
- Paints of your choice
- Sealer such as acrylic wax or Mod Podge
- Encaustic wax
- Wax remover
- Sandpaper and craft knife
- Copper relief foil (metal shim)
- Embossing tools and a paper stump
- Glass paint (optional)
- Alcohol inks

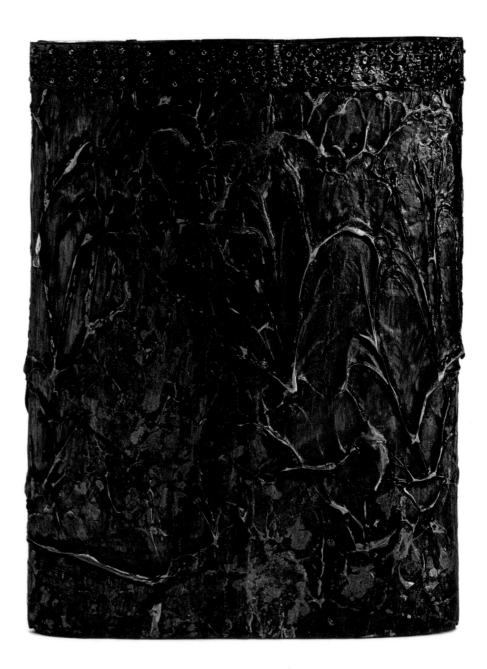

Right: *Bronze Vessel* by Isobel Hall.

## Instructions:

1  Spread light moulding paste on to Teflon.

2  Press the waxed sheet of kozo paper over the paste and use the flat palms of your hand to spread the paste. Leave some areas without paste, as this will give contrast. It will pull away like chewing gum.

3  Remove the paper from the Teflon sheet and leave it to dry. You will have some paste left on the Teflon. Leave that to dry or use a spatula to remove it and return it to the jar of moulding paste.

4  When the waxed and moulded paper is dry it can be coloured. Any paints that you use will react with the areas that are waxed and not covered with paste.

5  When the paint is dry you can stitch into the paper. You may want to use a stabilizer depending upon your ultimate aim. For *Bronze Vessel* (see page 49) Isobel did not want to use a stabilizer and so she stitched into it as it was. Any pin marks will show, so the best way to work is to make a needle-pricked hole on the front and then work from the back.

What you do next depends upon the finish you want. Isobel's vessel was painted with Mod Podge satin sealer.

## To continue in this way:

1  To highlight areas of texture, gold encaustic wax was ironed over the surface. To distress the paper, wax remover was liberally sponged in selected areas.

2  The paper was then lightly sanded. Where the wax remover has been applied it is possible to scrape off some of the wax using a craft knife. Often some of the bottom paint colour is also removed, which can give a wonderful distressed effect.

3  The interior of the vessel was lined with copper relief foil. A4 sheets of copper relief foil are only copper coated but you can change the colour using mixed media if you wish. Isobel used a paper stump to rub over the relief foil, which was placed over the pulled paste fabric. If you do not have a paper stump an embossing tool can be used but care should be taken not to pierce the copper foil.

4  When you have transferred the design on the paste to copper relief foil you can remove the copper foil and use embossing tools to add detail. Copper foil usually looks best if you have high peaks and troughs and add lots of detail such as tiny dots.

5  Colour the foil as desired. Isobel used blue glass paint and alcohol inks.

6  The copper relief foil around the rim was embossed, coloured and beaded.

# Ann Small

Ann Small has been working with textiles for many years and particularly enjoys teaching. Ann has won several awards including the National Embroidery championship and Embroiderers Guild President's cup. Her work has been selected for display in many national exhibitions.

Ann likes to work on large, bold pieces. She is highly skilled in free machine embroidery and manages to sew through most things including tomato purée tubes and other metals. She is also interested in fabric manipulation and layering. Her inspiration comes from various sources including architecture, African art and landscapes, allowing her chosen materials to influence the design process.

The inspiration for *Long Field* (see right) came as Ann sat for many hours painting in a field near her studio. Her eyes went repeatedly from distance to foreground, observing small pieces of coloured stone in the ploughed soil at her feet to the changing shadows of the distant trees.

Her three-dimensional textile accommodates two distinct ways of thinking. One involves the exquisiteness of repetition and pattern, which often creates an illusion of dimension and skilful placements of colour and form that can trick the eye into believing. The other element involves the structure of the work as the fabric is stacked, packed, stitched and snipped.

*Whelks on Islay* (see pages 54–55) is Ann's response to the fragility, diversity and spiral forms that nature has created in shells. She has endeavoured to encapsulate these wonders within the layers, surface texture and subtle colourings of her beautiful wall hanging. Both the scale of the work and the technique allows these textures to be appreciated at close hand.

Circles of fabric are cut, graded and coloured with rust. (Fabrics can be coloured with rust by wrapping them around old iron nails or old car parts and leaving to rust with the aid of vinegar). Each single piece has been sewn on separately, one at a time, to create whorls (a form that coils or spirals).

Colour and structure, as is the case with the source material, begins with its original hue and form, and is transformed and eroded by time and the elements.

Both *Whelks on Islay* and the *Long Field* series have been created with a combination of cotton poplin and cotton organza, which are perfect for this type of cut work.

Fine- to medium-weight natural fabrics perform well and they dye easily with Procion. Occasionally Ann will add small amounts of synthetic fabrics to liven the mix.

Right: *Long Field* by Ann Small, photographed by Art Van Go.

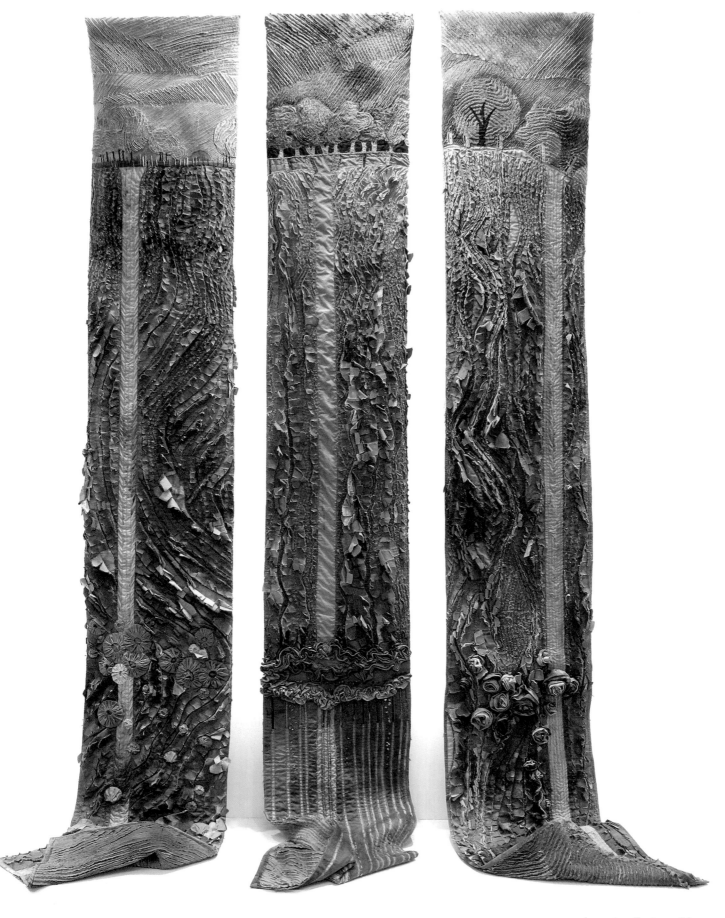

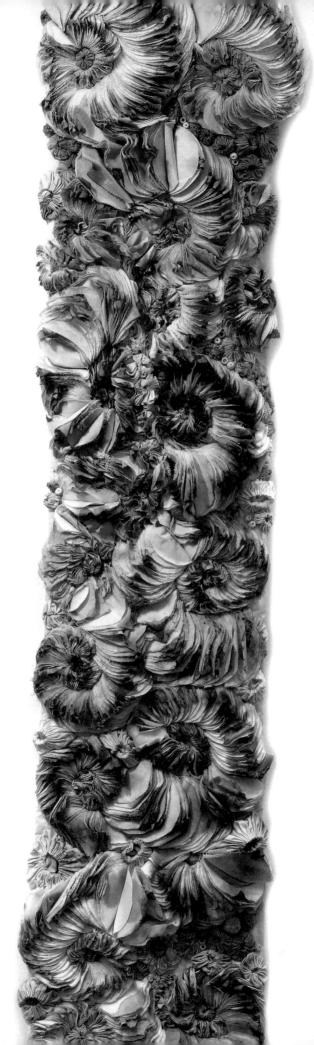

Right and far right: *Whelks on Islay* by Ann Small, photographed by Art Van Go.

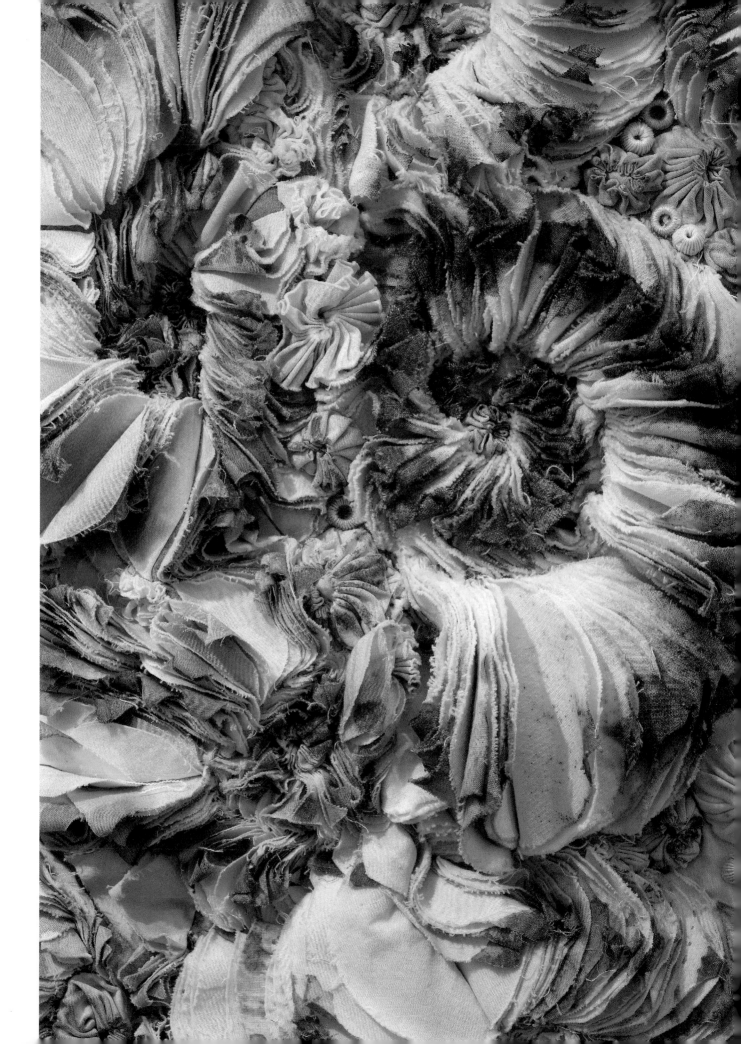

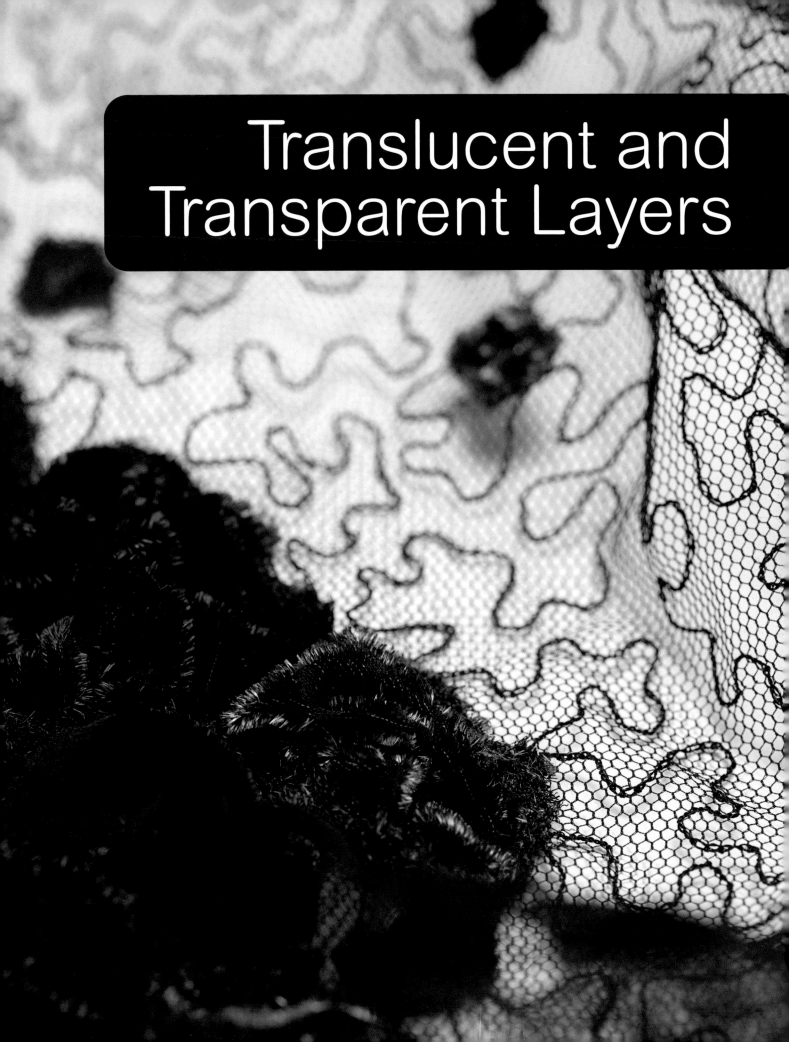

# Translucent and Transparent Layers

# Translucent and Transparent Layers

clear-cut, crystal, crystalline, diaphanous, glassy, limpid, lucent, lucid, luminous, see-through, semi-opaque, semi-transparent

Working with layers that you can see through can be a challenge but can also offer an opportunity. You need to consider how you will finish your work as any seams or stitching will be visible from all angles.

There are many products and fabrics available that are see-through. Some are stiff and hard to work with, while others are soft and floaty. The nature of sheer fabrics makes them more delicate to cut and sew than many other types of fabric. One of the precautions that must be taken when sewing sheer fabric is to avoid bunching at the seams and to create clean lines. Depending on the project and construction, sheer fabrics typically require some sturdier fabric as an underlay to support them.

Sheer fabrics come in a wide variety of colours, but white and shades of white tend to be most commonly available. These can be easily dyed, painted or printed.

Sheer fabrics may be embellished with embroidered patterns or designs. While embroidered sheer fabric is beautiful, it is extremely delicate and difficult to work with. With modern computerized sewing machines and more sophisticated fine interfacings and stabilizers, more can be achieved with fine fabrics than ever before.

Cutting sheer fabrics can be challenging. To provide a stable surface for cutting, sandwich the fabric between layers of tissue paper. Cut with your sharpest scissors, and keep the fabric stacked within the paper until you are ready to sew. Always sew fine fabrics with a fine sharp needle whether working by hand or machine.

Left: Layers of Vilene Spunbond CS500 in seven pre-dyed colours zapped with a heat gun to reveal transparent layers.

Right: Hot Spots! ironed on to black Vilene Spunbond CS500 and decorated with heat transfer foil, sequins and glitter. The whole piece was then zapped with a heat gun to create a distressed effect.

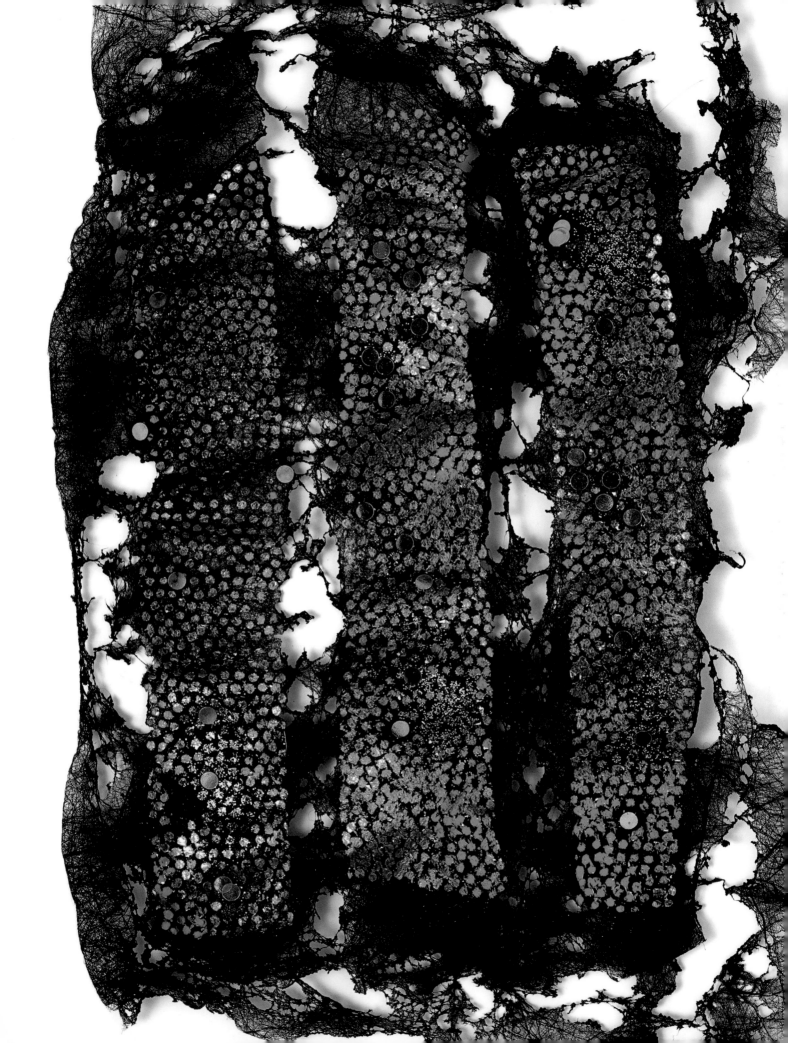

## Vilene Spunbond

The new generation of synthetic Spunbond fabrics range in weight from the finest translucent, floaty CS500 to the heaviest CS800 (see also page 44). The fine CS500 is now available in colours, which are a great addition to the Vilene Spunbond line as the finer weights can be difficult to colour because they are so fine and lacy. It is difficult for the paint to cling to such fine threads. The coloured Vilene Spunbond makes an excellent background for painting, printing and spraying. One of the best features of this product is that it doesn't fray. Anyone who works with polyester organza regularly knows that the threads will follow you around for hours after you have worked with it.

## Lamifix

Lamifix is a relatively new product in the textile world. It is a clear iron-on plastic film that can be used to protect your work and make it waterproof. Because it is a fusible product it can also be ironed to itself to create a very firm material that is suitable for making boxes. Glitter, sequins and small fabrics snips can be trapped between the two layers before you iron them together. Always use baking parchment when ironing Lamifix. Lamifix can be cut with scissors but can also be cut with the hole punches used in the card-making industry and die-cutting machines. If you are feeling adventurous, Lamifix can also be transfer printed and then shaped while it is hot – but be careful not to burn yourself with hot plastic!

Below: Heart-shaped box created by trapping sequins and glitter between two sheets of Lamifix. The box shape was cut with a die-cutting machine.

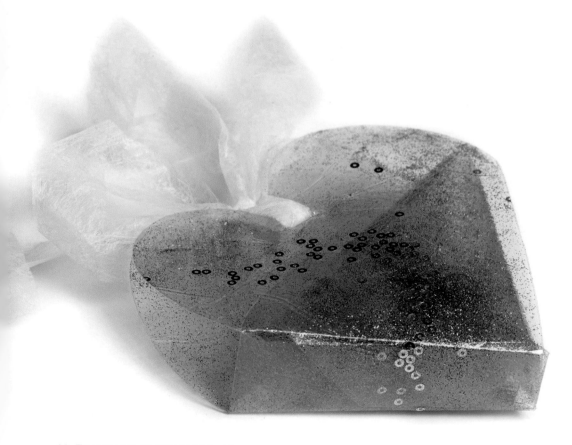

Lamifix is a protective product that also strengthens your work. It is sold by the metre and is very useful for finishing off bags of all kinds due to its strength and waterproof qualities. Decorated Bondaweb is so fragile and Lamifix is excellent for protecting this decorative process. Once ironed on to your work it will make it stiffer but your fabric will still remain pliable.

Below: Painted Bondaweb ironed on to a black cotton background and decorated with sequins, glitter and heat-transfer foils. The Bondaweb background was protected by ironing Lamifix gloss all over. The bag pattern pieces were then cut out and the bag was machine stitched together.

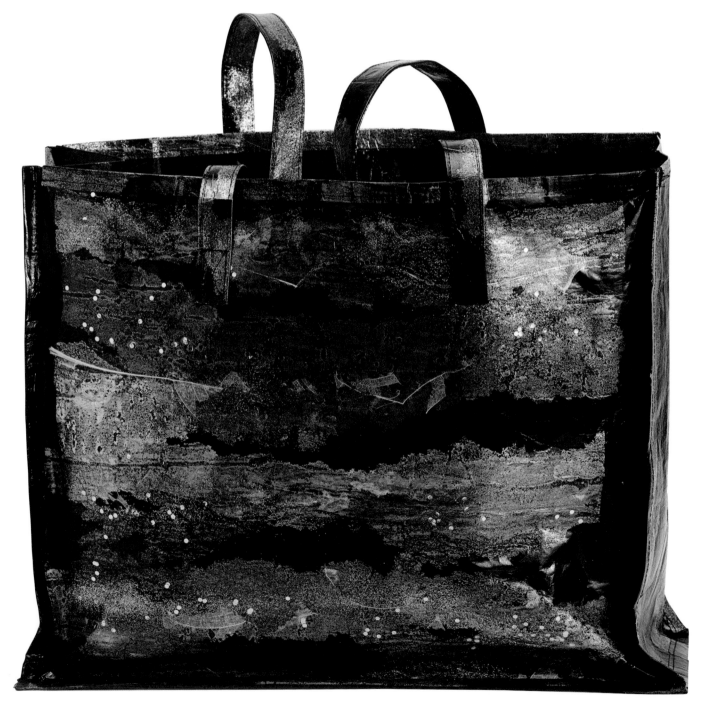

## Polyester organza

Although it can fray and follow you around for days, polyester organza is a versatile sheer fabric. It can be cut into very intricate shapes and fused with a fine-tipped soldering iron and distressed beautifully with a heat gun. For more information on this technique, see *Fusible Fabrics* by Margaret Beal (see Further Reading, page 124). Polyester organza is available in a rainbow of colours that sparkle and twinkle and can lift a dark corner of your work. It can be transfer printed very successfully but you need to take care that you don't melt the fine organza on to the transfer paper.

One of my favourite ways of working with polyester organza is to apply painted Bondaweb and decorate this with heat-transfer foils and sequins, then zap and distress the work to cut it into strips. The strips can then be stitched together to create larger areas. Because you are working with distressed polyester the work is strong but lightweight and can be used for all manner of projects. Polyester also offers a wonderful contrast when working with papers, particularly newspaper. The contrast of the rich sparkly colour of the organza and matt and dull newspaper is very attractive.

Right: Strips of coloured polyester organza decorated with painted Bondaweb, glitter and heat-transfer foils. The sections were heat gunned around the edges and across the decoration and carefully hand stitched together.

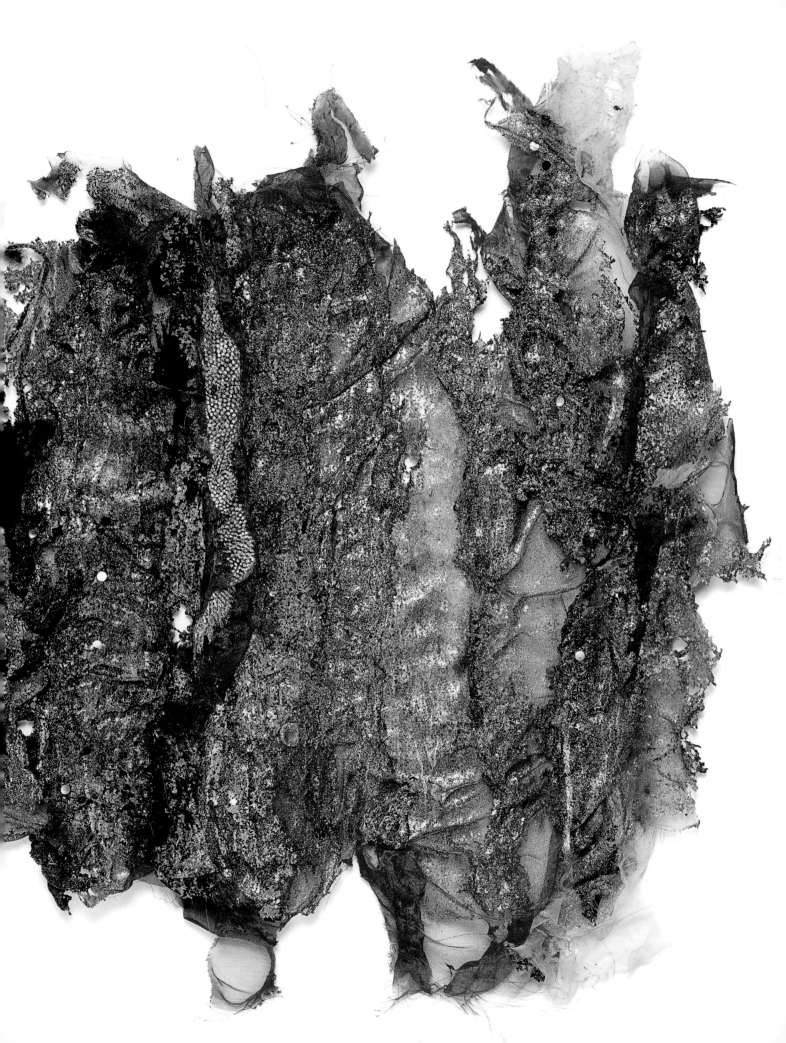

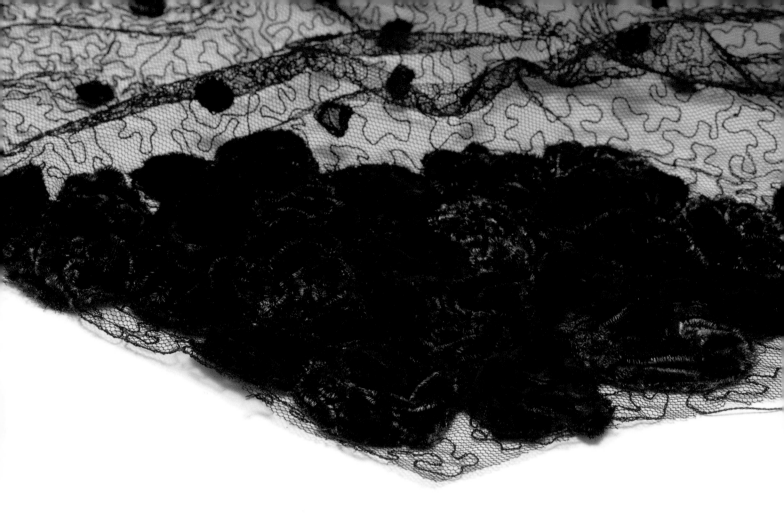

# Cherrilyn Tyler

Cherrilyn Tyler has been a practising textile artist and teacher for over 20 years. She works with machine embroidery, combining the fine stitch from the machine with the texture of hand work. Cherrilyn's work has been widely exhibited both in the UK and in Australia.

Her work has an ethereal quality. She uses a very delicate colour palette and fine fabrics based on quality of stitch and design. Cherrilyn works with transparent fabrics because she likes how the work looks fragile but is actually quite strong. The fact that you can see the structure of the fabric often determines the function and purpose of the piece.

With transparent fabrics there is no hiding place for bad stitch and Cherrilyn welcomes this challenge. It is the ever-changing aspect to the work, determined by what lies behind, that she finds exciting, together with the shadows made by fine thread looking so strong and defined.

She also feels that the transparency allows the viewer to add to the work by placement or thought. As Cherrilyn designs from personal concepts the transparency means that her thoughts may or may not be seen, and she likes the fact that the transparency seems to reveal all but actually allows the thought to hide.

This work is inspired by the strength of women at the beginning of the 20th century contrasting with the fragility of the individual women that make up this movement. The visual impact of these pieces is made by strong shadows formed from a single thread. The bodices celebrate femininity, a powerful force.

The delicacy of the fabrics and their manipulation combines and draws the onlooker into the work, allowing them to merge with the concepts and consider their own relationships.

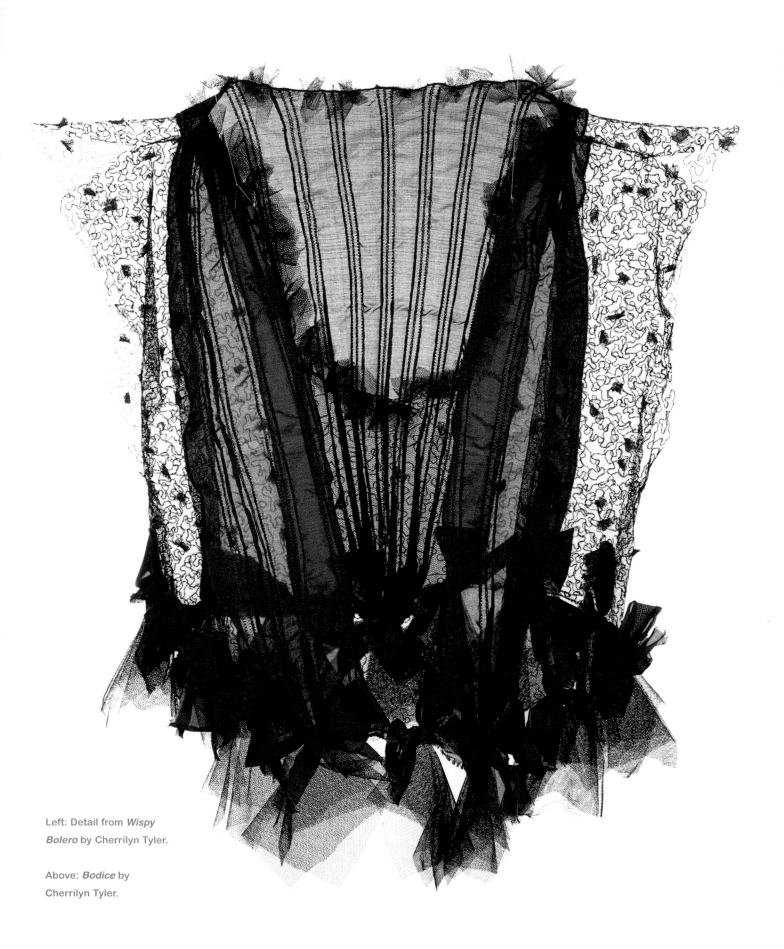

Left: Detail from *Wispy Bolero* by Cherrilyn Tyler.

Above: *Bodice* by Cherrilyn Tyler.

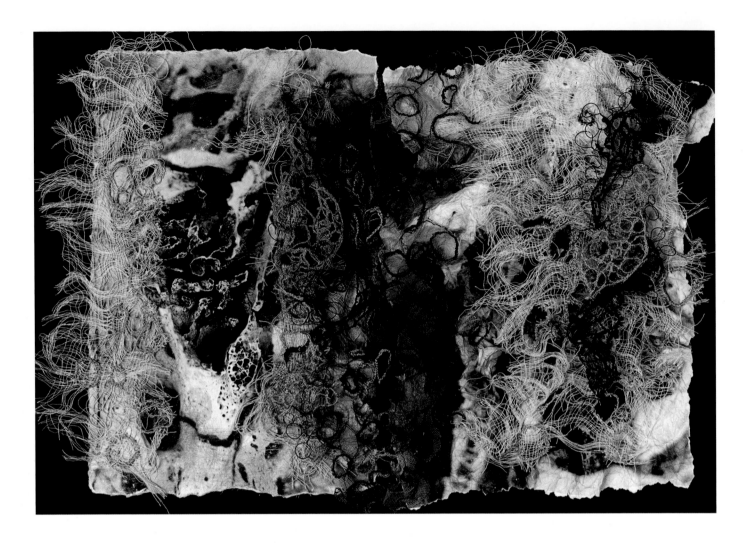

# Doreen Woodrow

Doreen Woodrow is a textile artist who excels at observational drawing and 'looking at things from a different direction' as a basis for her work in textiles.

The work featured here is all about holes in animal skulls and shapes within the holes. Doreen's interpretation of this includes photographs, drawings, free machine embroidery and hand stitch.

Scrim was layered with a water-soluble stabilizer and free machine embroidered to create holes. The stabilizer was then washed away and the embroidered scrim was then stitched on to the work. Very fine rings of free machine embroidery were also created by embroidering directly on to the stabilizer. It is important to make sure that all your stitches join together and overlap with this technique, otherwise when the stabilizer is washed away, your stitches will unravel. This a very delicate process but it is worth persevering as the effect can be quite beautiful, as you can see from the frothy effect on Doreen's work.

Above and right: *Delicate Decay* by Doreen Woodrow

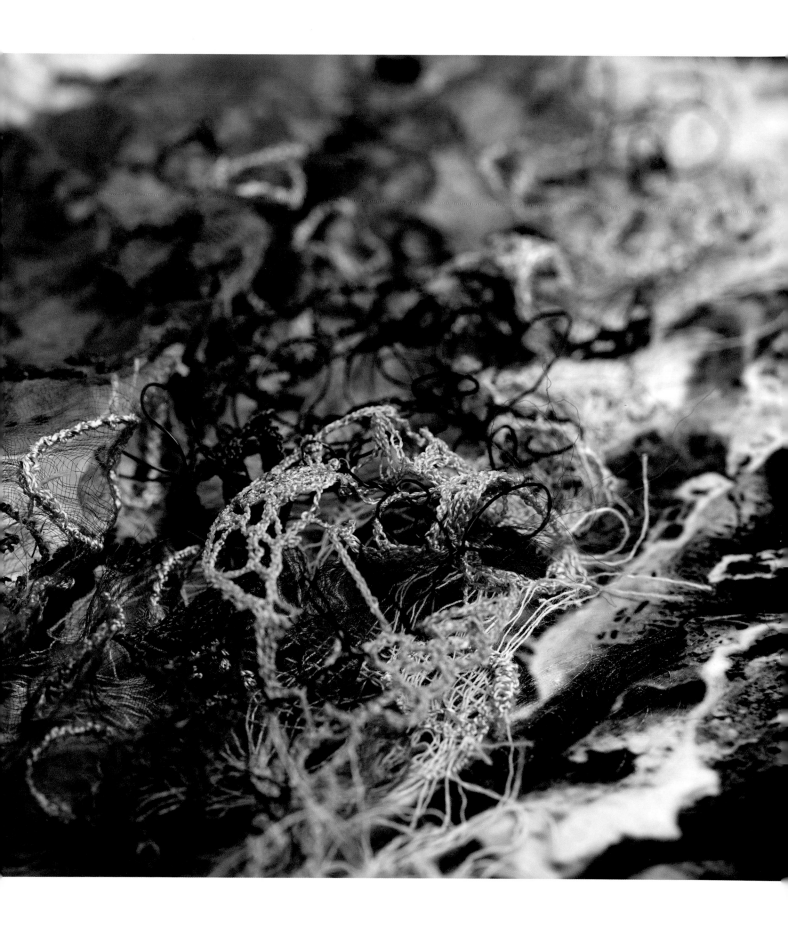

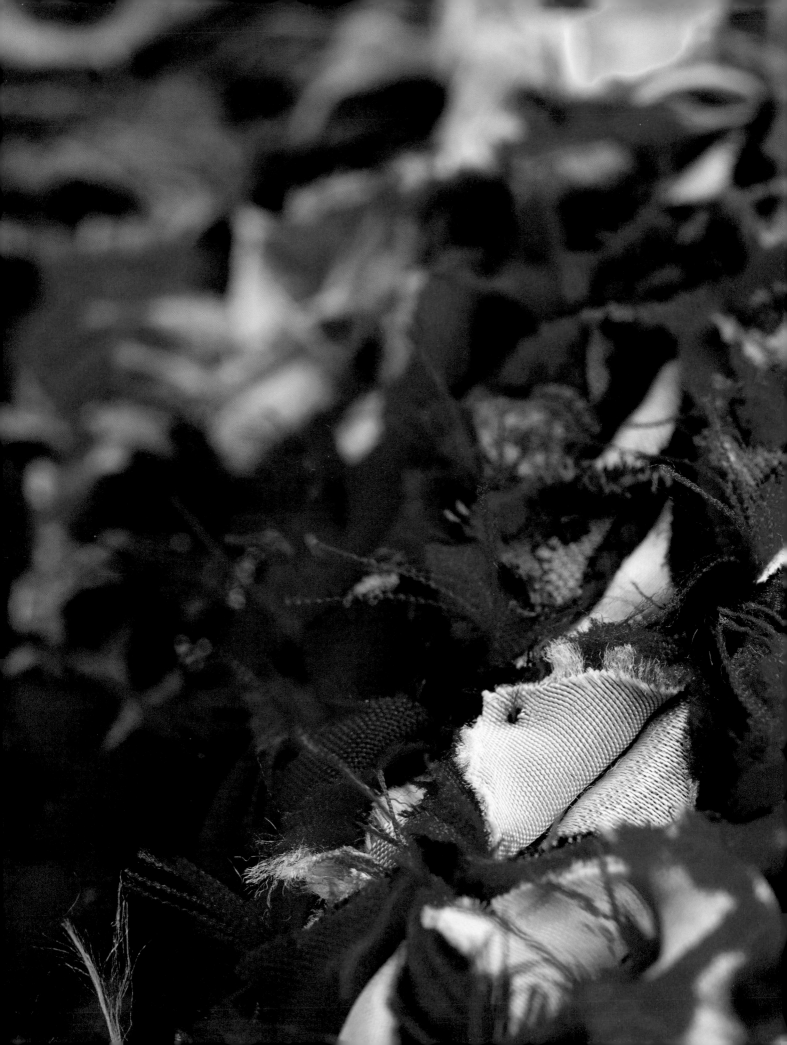

Recycled
Layers

# Recycled Layers

convert, reclaim, recycle, recondition,
recycle, redeem, regenerate, remodel,
reprocess, rescue, restore, salvage

There is something very satisfying about making a beautiful piece of work from recycled materials, and this is not just because the materials are free. In this section we will look at making layered pieces using newspaper, other types of paper and recycled fabric.

## Recycled newspaper

Do you use newspaper to protect your work surface when you paint and dye your materials? What do you do with the newspaper when you have finished painting – do you throw it away? Don't! Stitch it.

I have become so enamoured of decorated newspaper that it is all I want to work with at the moment. I tend to use the same newspapers as a background for painting over and over again until there is a fabulous build-up of random paint and dye covering the entire surface. Images become disassociated from text and wonderful things happen when you start to tear and stitch into it. Because newspaper is quite fragile it can be torn very successfully. If you need a firmer background the newspaper can be backed on to a sew-in or iron-on interfacing.

Decorated newspaper is particularly fascinating when combined with painted Bondaweb. Small sections of an image can just be seen and odd words of text can peek through to create something quite splendid.

One of the techniques you can try with decorated newspaper is faux chenille, which is perhaps more usually done with fabric. Using this exciting technique with newspaper gives a fantastic peeling paint effect. When combined with polyester organza it is extremely impressive.

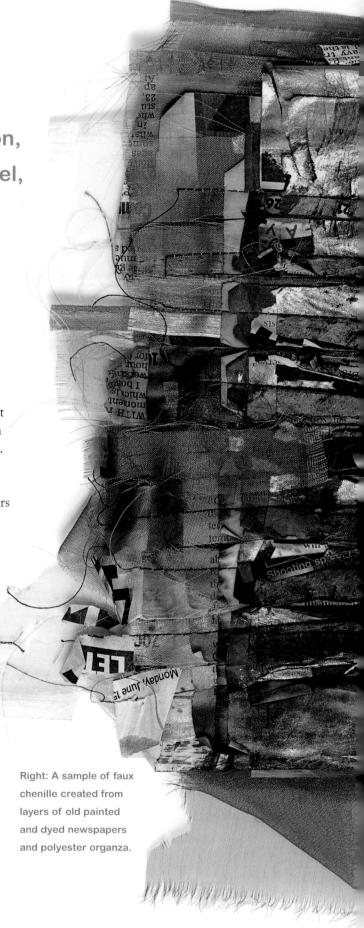

Right: A sample of faux chenille created from layers of old painted and dyed newspapers and polyester organza.

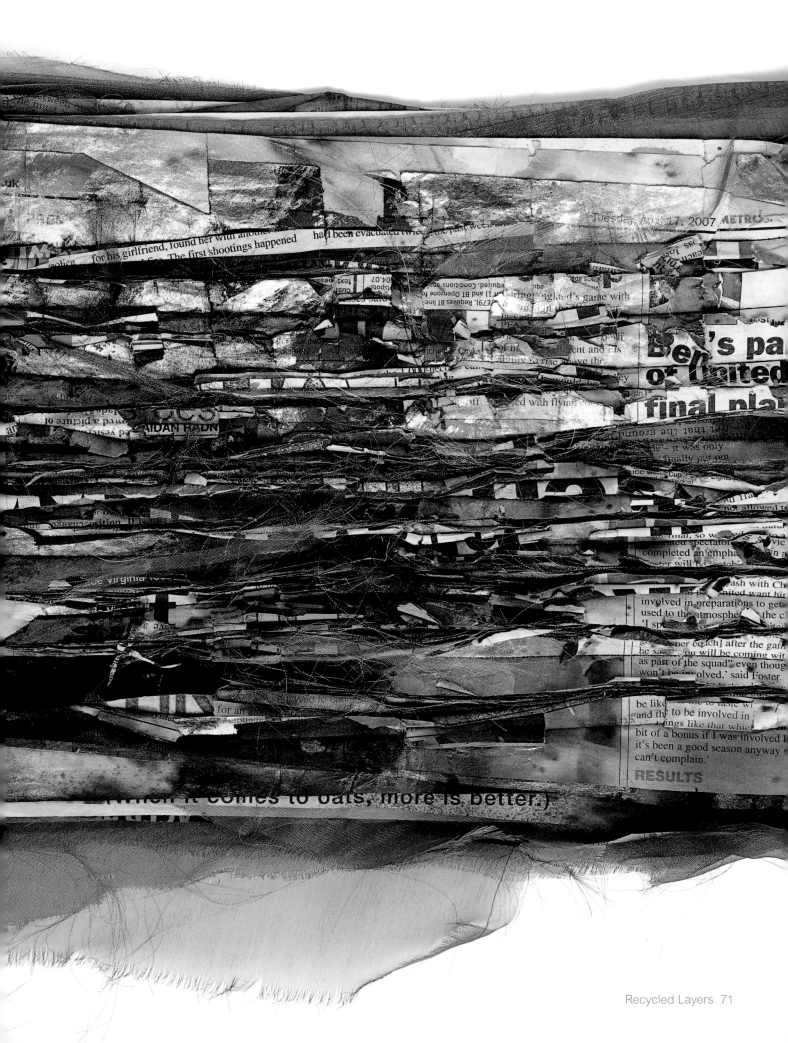

# A faux chenille sample

## You will need:

- An A4 medium to heavy sew-in interfacing pre-dyed/coloured as a background
- A minimum of eight A4 sheets of newspaper
- Pins, if necessary
- Sewing machine
- Scissors

## Instructions:

1 Use the interfacing as your base and then layer with the sheets of newspaper. If you need to, pin them in place so they don't slip about, but be careful of the pins when stitching as you don't want to break your machine needle.

2 Stitch parallel lines of stitch down the length of the sample approximately the width of your machine foot, no narrower.

3 Once you have stitched the whole piece, very carefully cut through the newspaper but not the interfacing. Once all the channels have been cut you can distress your sample as much as you dare to with a wire brush or teasel. Try to make most of the layers stand up so that each layer is visible. Work very steadily and build up slowly; don't forget you are working with quite a fragile material.

4 Once you have tried one sample, try layering different materials such as colour magazine paper and polyester organza between some of the layers of newspaper. Sparkly polyester organza is an effective contrast to the dull, matt texture of the newspaper and it frays well when distressed with a wire brush.

Because you are layering several materials together your work can become quite stiff and will therefore be very useful for three-dimensional projects. The larger the piece of faux chenille the greater the possibilities are for creating quite striking pieces of work. Smaller samples can be used in sections to help give a lift to a piece of work. Larger pieces can become quite stunning vessels. When made with fabric rather than paper the material remains soft and pliable (see Ann Small's work on page 53).

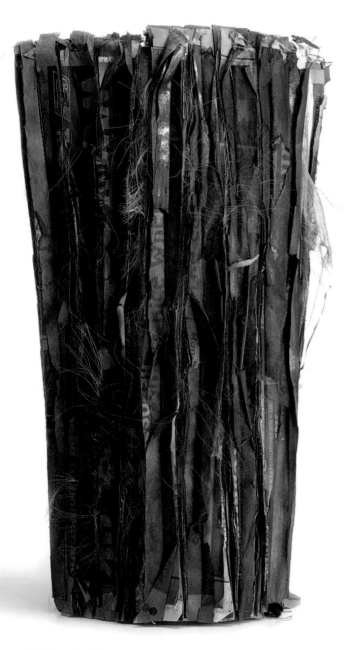

Left and right: A basic faux chenille sample vessel created from layers old dyed newspaper and polyester organza.

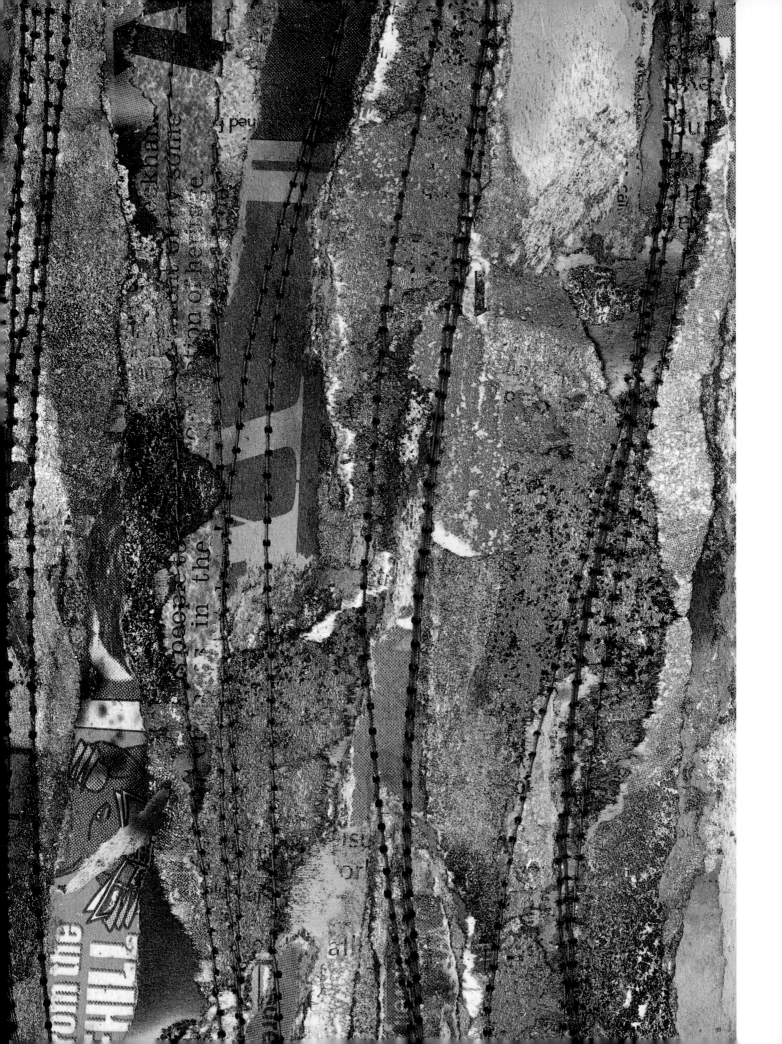

# Using painted Bondaweb

As we have already seen, painted Bondaweb is an incredibly versatile medium and when teamed with decorated newspaper it gives added depth both in colour and strength.

The combination of Bondaweb and layers of newspaper produces a material that will withstand quite a lot of wear and tear, particularly if it is sealed with acrylic wax or a non-yellowing varnish. The finished result can be cut with scissors or a scalpel, or the edges can be left in their torn condition. It depends if you want a sharp or an organic look. Try making boxes or book covers with your first samples and see what other ideas come through. Your work will always need to be sealed as the Bondaweb needs to be protected.

Left and right: Strips of old painted and dyed newspaper fused together with painted Bondaweb. Machine stitch adds definition.

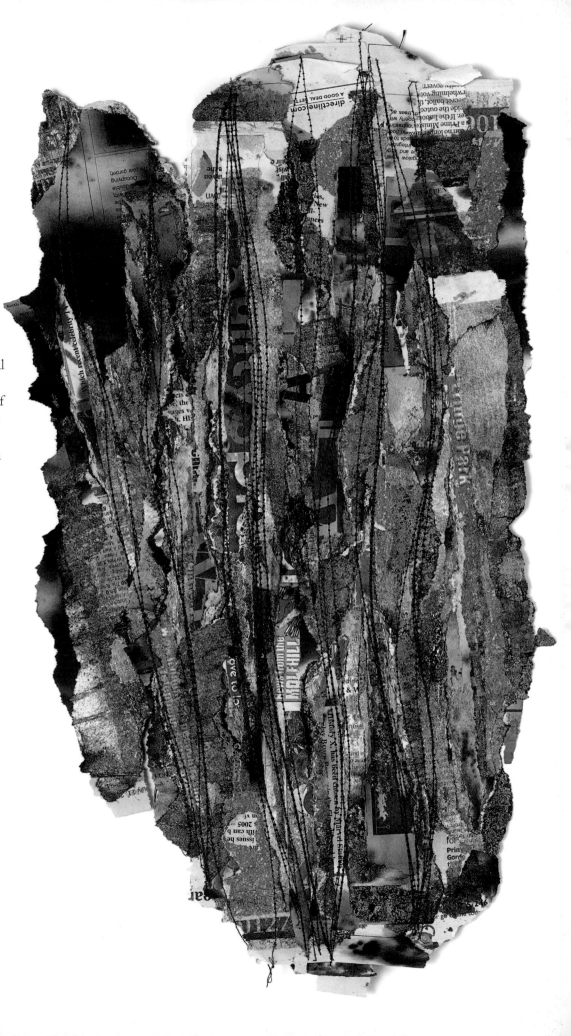

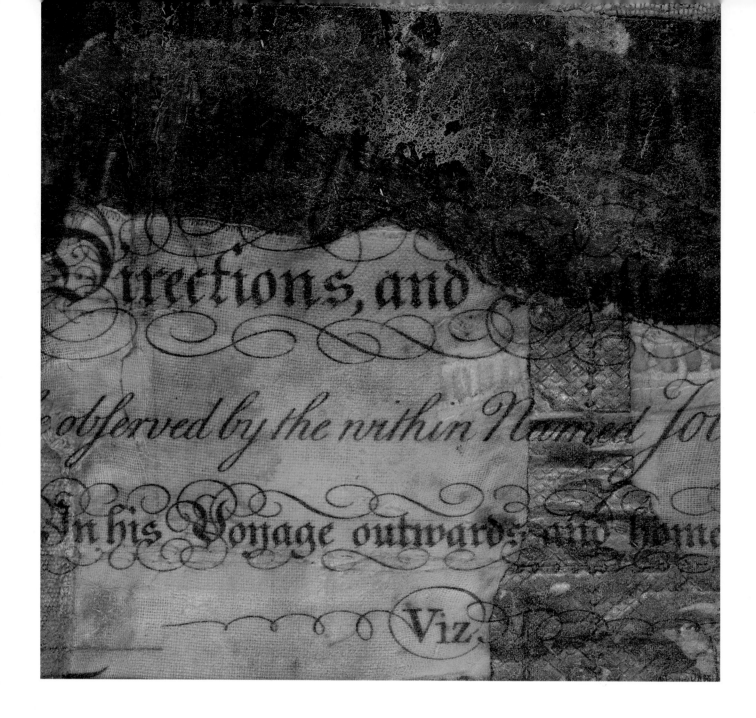

# Alix Mercer-Rees

Alix Mercer-Rees brings many techniques and media together in her work. She experiments with a plethora of mixed-media collage techniques, inspired by a colourful palette of urban graffiti and everyday life, incorporating freestyle print and stitch to embellish and express her creative ideas.

Once you have had fun creating interesting materials using recycled paper, the next step is to combine recycled paper with fabric to achieve even more exciting and unexpected results. The possibilities are endless.

When photocopying documents or other papers do remember to consider copyright restrictions.

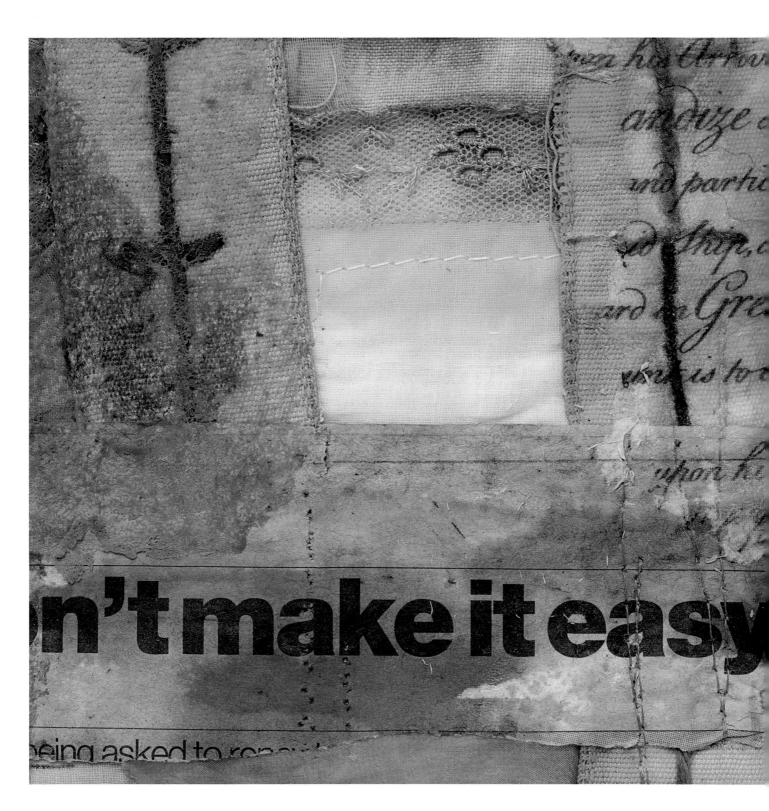

Above left: *Directions* by Alix Mercer-Rees. Dyed and photocopied old documents that have been layered and pieced together with painted Bondaweb to create fascinating textures.

Above: *Don't Make It Easy* by Alix Mercer-Rees. Combined fabrics, newspaper and documents, dyed and stitched by hand and machine.

# Sylvia Lynton

Sylvia Lynton's beautiful wall pieces are based on gardens; her work is made from old dyed papers and fabric and then mounted on canvases. The never-ending supply of images around us gives Sylvia all the inspiration she needs to interpret what she sees using pieces of old envelopes, doilies and any fabrics that come to hand. All the papers and fabrics are dyed with Procion dyes and then pieced together to represent the image Sylvia is working on.

Her expertise in painting has affected how Sylvia works with textiles and she prefers the more tactile feel of fabrics. The immediacy and unexpected juxtapositions of colour she finds while piecing together her work is what drives Sylvia to create more and larger work. The fabric pieces, either dyed or intrinsic, can be manipulated for colour and shape in a very different way to paint, and dyeing in itself produces unexpected results. In addition to working with orthodox materials Sylvia likes to work with found pieces, some marked with age and decay. She tends to work with layers, set into boundaries of margins and edges.

Sylvia's interest in gardens is life-long, and although her work is varied, she returns again and again to the outdoors as a theme to be explored.

Above: *Path Through the Park* by Sylvia Lynton.

Above: *Late From the Hyacinth Garden* by Sylvia Lynton.

# Fay Maxwell

Artist Fay Maxwell has been teaching embroidered textiles techniques for the past 15 years and sells her work worldwide. Her workshops are designed to encourage students to explore new and unusual avenues and to rely on the happy accidents that occur along the way. Fay enjoys taking traditional techniques from many cultures and combining them into new formats, experimenting with modern fabrics and changing textures with the addition of unusual effects.

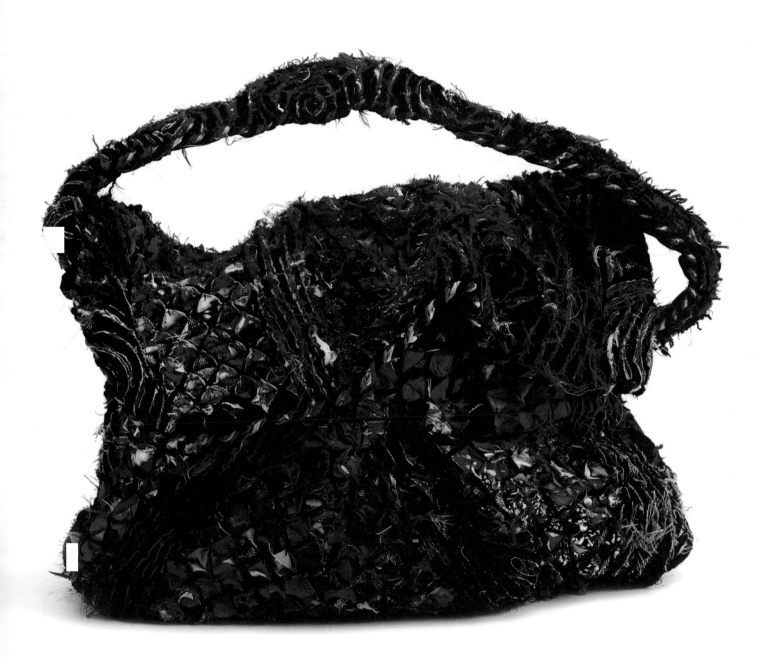

Left and above: *Fay's Bag* by Fay Maxwell.

Fay's work is usually bright, colourful and full of exciting textures. Her combination of faux chenille and slashing has created a new interest in layering textiles. Fay uses anything and everything she can find in creating her work. Generally she uses a heavier weight base to layer a crazy mixture of natural and synthetic fabrics in bright, exciting colours.

This bag was made with layers of colourful synthetic and natural fabrics machine stitched together and then slashed a cut to create amazing textures. The resulting fabric was then cut into pattern pieces and the bag was constructed.

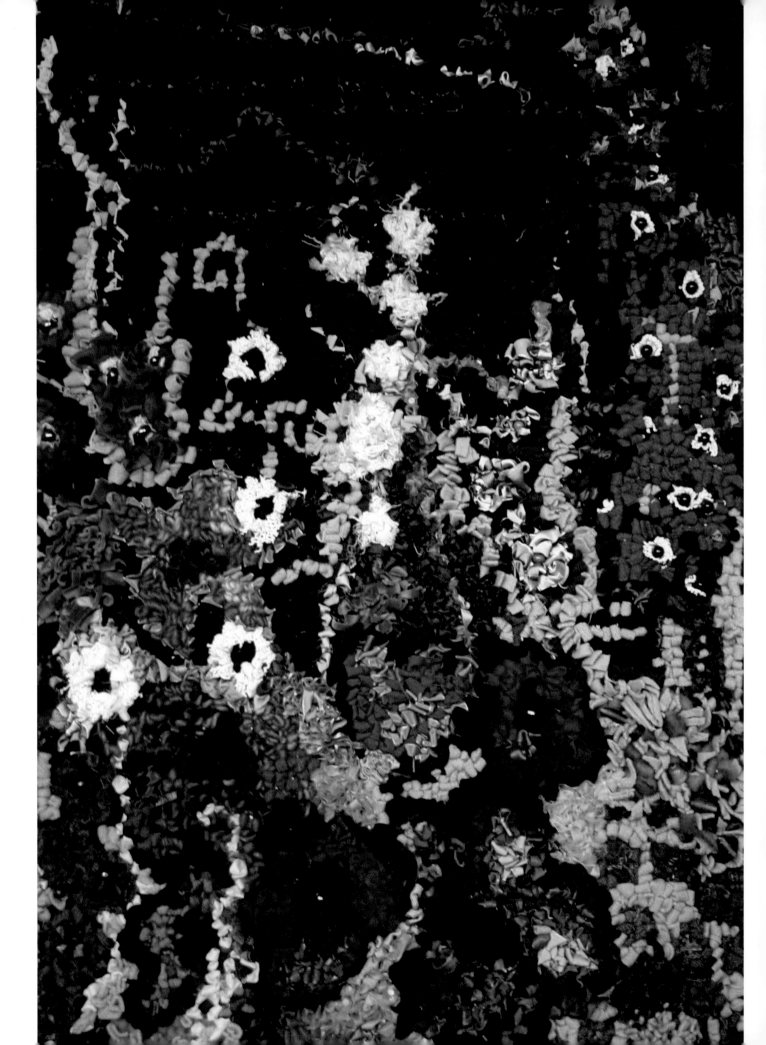

# Recycled fabric

## Quilt making

Quilt making has always been a popular way to recycle old clothes and fabrics; crazy patchwork is a particular favourite, where odd-shaped and sized fabric scraps are placed randomly on a background and stitched into place. The patchwork can then be embellished with buttons, beads and all kinds of hand stitch. It is a wonderfully free way of working and fantastic for using up all the small scraps in your rag-bag that you can't find a use for but can't bear to throw away. With the advent of double-sided fusible fleece it is now possible to iron your scraps directly on to the fleece and then iron this on to a lining, negating the need to use pins or tacking to keep the scraps in place.

## Rag-rugging

Rag-rugging is another technique that uses up old fabrics. The technique originated as 'thrift craft' in a similar way to patchwork quilts. The history of rag-rug making goes back hundred of years; old clothes, bed linen, wool or any old cloth found around the home were used to make rugs, which could be plain or colourful. Making rag-rugs was a way, initially, for poorer families to create bed coverings or floor rugs from old clothes and fabric scraps. Its precise origins are uncertain, but links have been suggested with Viking settlers.

Because the craft was seen as a 'poor' craft, it was never valued at the time, so few examples were kept or collected. However there are some still conserved in several museum collections around the UK. For example, there is an excellent permanent collection of old quilts and rag-rugs at the American Museum near Bath.

Instead of throwing materials away or sending them to be recycled, rag-rugging is an enjoyable and useful craft, which uses them all up.

There are two basic techniques to try; hooking and prodding. With the hooking technique you work from the front of your rug and hook the fabric strips from the back to the front with a latch hook. With the prodding technique you work from behind and push your fabrics through to the front. The original materials used to make rag rugs were anything that came to hand but there is now a never-ending choice. The original thrift rugs were made using old flour or grain sacks as a backing; modern rugs can be made the same way or you can use a rug canvas specific for the craft.

# Reduce, reuse, recycle

It has never been more important for us all to make an effort to recycle everything we possibly can, and to do so creatively will add so much more pleasure. We can donate our old clothes and household linens but it would be much more fun to cut, tear, embellish, stitch, piece, hook, quilt, fray, bond, apply ... and layer.

Left: *Summer Border* by Clare Rose. A hooked rag-rug created from old fabrics with beads added for definition.

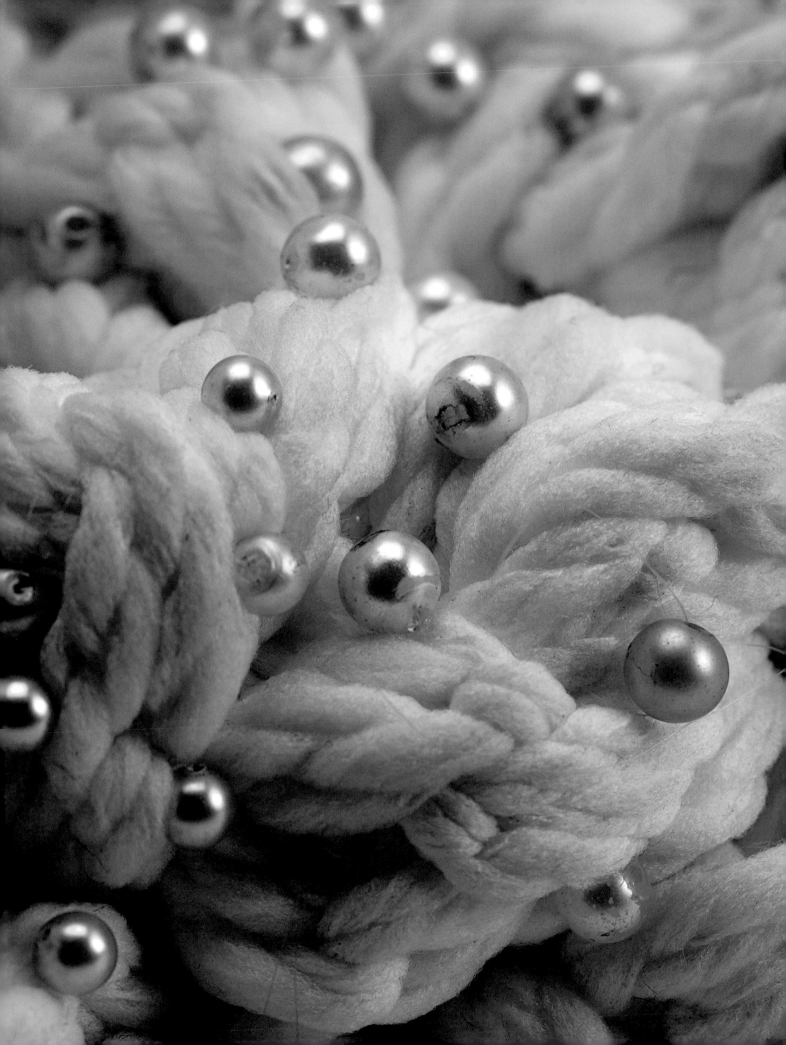

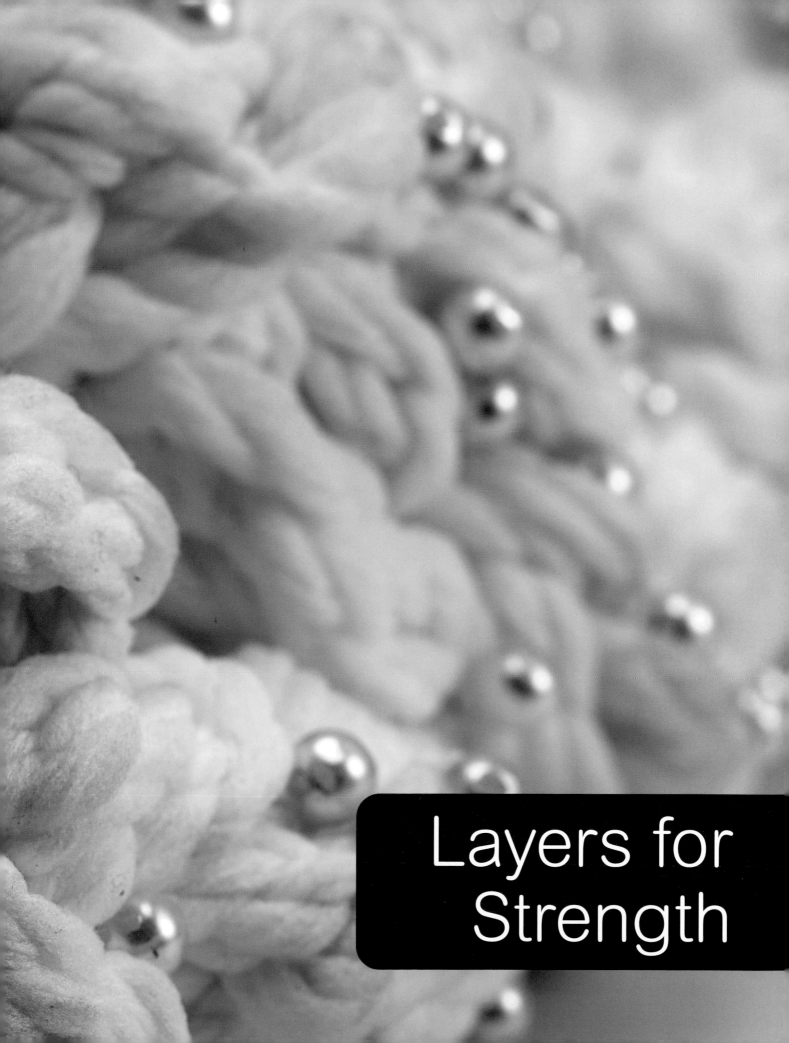

Layers for
Strength

# Layers for Strength

**durable, enduring, firm, fixed, hale, hard as nails, hardy, heavy-duty, reinforced, robust, rugged, secure, solid, sound, stable, sturdy, substantial, tough, unyielding, well-made**

Fabrics have been layered for thousands of years for strength. For protection and warmth there is felt; for strength and decoration there is mola work or reverse appliqué. Nowadays, with modern technology and fabrics we have no need for heavy, thick fabrics to keep us warm and protect us, but we are still drawn to layer and decorate.

By layering or laminating products and processes you will be creating a strong and usually pliable fabric on which you can stitch and manipulate. A laminate is a material that can be constructed by uniting two or more layers of material together. It is not necessary to create many layers before you have something really quite strong.

## Tyvek

Tyvek is 100 per cent spun polyethylene and is a popular product as it heat distresses so well (for instructions on making a layered sample, see page 43).

The heavier weight pre-cut A4 Tyvek sheets can be run through an inkjet printer with great success, but don't put Tyvek through a laser printer or a photocopier as they use heat to print and would cause the Tyvek to melt inside the machine. Your inkjet-printed image can be layered with more Tyvek and other heat-distressable fabrics and then zapped with a heat gun to create areas of interest.

Right: Three layers of 75gm Tyvek with layers of polyester organza between layers. The sample was machine stitched together in a spiral design, then zapped with a heat gun.

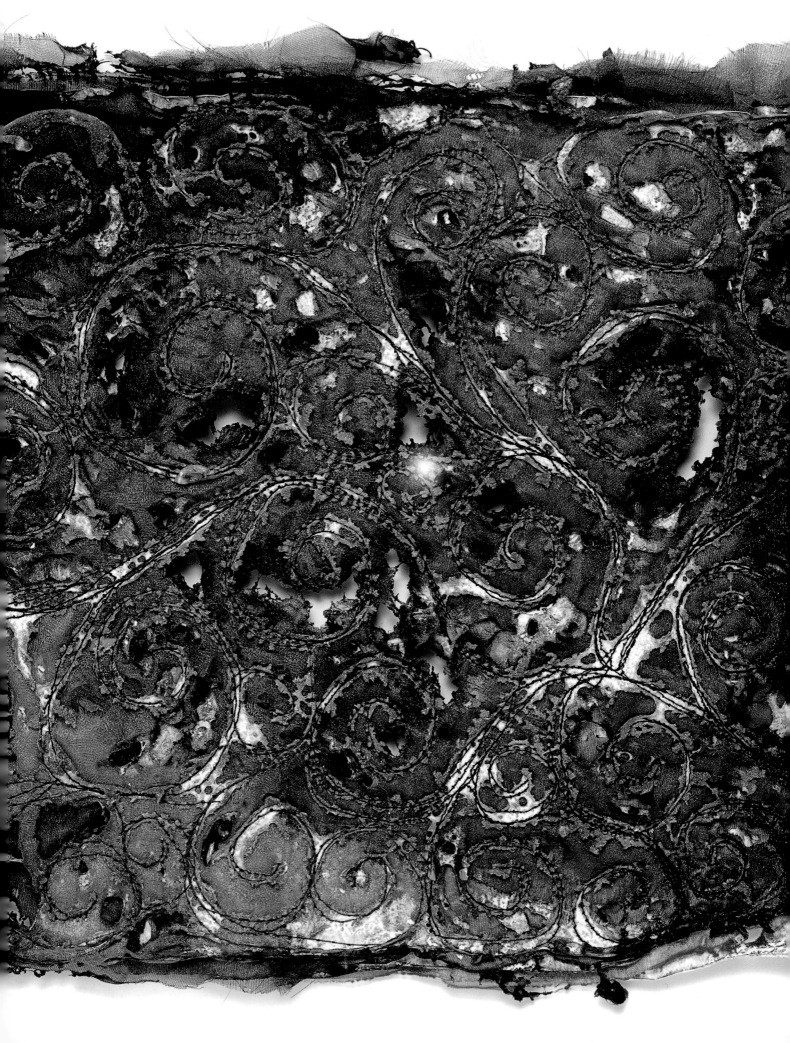

# Vilene Spunbond and interfacings

Layers don't have to be the same shape and size to be effective. Layering thin strips can create strength as well as wider sheets. Vilene Spunbond is a good example of a fine fabric that becomes very strong as you layer it up. Using a dyed iron-on interfacing as a background, cut strips of various weights of Vilene Spunbond with a soldering iron and iron it on with baking parchment. Not only do you have ann attractive decorative surface but also a strong one.

To apply thin strips to a non iron-on background such as the heavier Vilene Spunbond CS800, iron Bondaweb on to the back of the fabric you are going to cut into strips. Cut your strips either with scissors or a soldering iron, remove the backing paper from the Bondaweb and iron on to your background using baking parchment. If you have used all synthetic fabrics in your work you can then distress it with a heat gun.

Heavy iron-on or sew-in interfacings make a fabulous support for larger projects. These interfacings can be dyed, painted, printed and sprayed. They can also be transfer printed with disperse dyes. Try cutting out shapes with a soldering iron. Even the heaviest weight interfacings can eventually be cut; it will take time as the heat takes a while to get through but you can create a very decorative edge.

The iron-on interfacings can be decorated in the same way as painted Bondaweb (see page 18).

Far left: Painted and dyed craft Vilene and Vilene Spunbond CS700, cut to shape with a soldering iron and ironed on to dyed heavy iron-on interfacing.

Left: Various weights of Vilene Spunbond painted and ironed on to Bondaweb. The Vilene Spunbond was cut to shape with a soldering iron, removed from the Bondaweb backing paper and ironed on to dyed Vilene Spunbond CS800.

Right: *Flight* by Kim Thittichai. Silk fibres were ironed on to two panels of pre-dyed heavy iron-on interfacing. The shapes were cut from one of the panels with a laser cutter. The two panels were stitched together and fixed on a specially made lamp base.

# Felt

Felting is the process of tangling fibres. Wool felt has the ability to protect against heat and insulate against cold. It absorbs and holds moisture, and felt can be cut without fraying or unravelling.

Felt in its many forms has been used for thousands of years because of its versatility and strength. It is one of the oldest fibre crafts, dating back as far as 6,300BC. Felt making predates spinning, weaving or knitting, and for centuries this non-woven fabric has provided for basic human needs, such as yurts (felt tents), rugs, hats and footwear. Layers of wool are built up and, with some elbow grease and patience, they are combined to make a sturdy fabric (see page 36).

Mongol tribes in the desert have made felt for their yurts, by rolling wool around large logs and dragging this behind horses; the heat and friction of this most basic of felting techniques created a very strong and hard-wearing material. Cowboys riding the plains used to make felt by placing the wool tops underneath their saddles and the heat from their horses' backs helped to make the felt. The medieval way was to tramp the wool in a vat of urine. Luckily in this modern age we can bypass these rather archaic methods and buy wool tops prepared ready for felting with no need for noxious or arduous processes.

# Jayne Routley

Jayne Routley is a textile artist and tutor. As Lady Lazarus she is well known for her needle felting and nuno techniques, creating humorous fish, sheep and human figures as well as the more traditional techniques of a felt maker. Jayne exhibits nationally and is founding member of the exhibiting textile group Threads.

The name 'nuno' is derived from the Japanese word for cloth. The technique bonds loose fibre, usually wool, into a sheer fabric such as silk gauze, creating a lightweight felt. The fibres can completely cover the background fabric, or they may be used as a decorative design that allows the backing fabric to show. Nuno felting often incorporates several layers of loose fibres, combined to build up colour, texture and design elements in the finished fabric.

The nuno felting process is particularly suitable for creating lightweight fabrics that can be used to make clothing. The use of silk or other stable fabric in the felt creates material that will not stretch out of shape. Fabrics such as nylon, muslin or other open weaves can be used as the felting background, resulting in a wide range of textural effects and colours.

This strong but beautifully lightweight scarf by Jayne has been constructed using the nuno technique of combining wool fibres with fabric. Here, soft chiffon is trapped between many fine layers of wool and bamboo. It was hand felted with water – unlike *Mandarin Fish* (see pages 92–93), which was dry felted – and finally a gentle machine wash brings all the fibres together. The wool works its way through tiny holes in the fabric weave to create a new fabric.

**Above: Scarf by Jayne Routley. Combined layers of chiffon and wool tops with added silk fibres for decoration.**

# Needle felting

The felting needle was invented for industrial use; to enhance and expand the felting process so that synthetic and plant fibres could be felted. A felting needle has barbs all the way along it and is used in a sharp up and down motion on a firm sponge. The sponge must be deeper than the length of the needle. Needle felting is a dry method of making felt and is particularly useful for sculpting shapes. It gives you an element of control that you don't have with wet felt.

Needle felt is a fascinating way of creating three-dimensional wool sculptures. *Mandarin Fish* (see right) is built up of many different layers of wool. Starting with a simple ball of wool tops, base colours are gently needled on to the surface. Tails and fins are made separately then the pieces are attached and blended into the main body. Once the eyes and mouth are attached, the final layer design elements and patterns are added by streaking lines and spots of contrasting wools across the surface.

Right: *Mandarin Fish*
by Jayne Routley.

# Working with needle felt

Depending on the weight, thickness and type of wool you are felting you will either need a finer or heavier felting needle. The finer the wool the finer needle you will need.

For this project a 38-star needle was used for constructing the main body and a 36-star needle was used to create the embellished decoration and fine detail work.

Most shapes can be started from the same simple point. When needle felting, place your sponge on firm, hard surface (not your knee). Place the wool shape you wish to felt on to your thick sponge and stab with the needle in regular movements. The barbs on the needle will start to felt the wool. Have regular rests – this technique can give you repetitive strain injury.

**Warning:** Felting needles are very sharp.

## You will need:

- **White Cheviot wool tops**

- **Thick car-washing sponge (must be as deep as the length of the needle)**

- **36-star and 38-star felting needle**

- **Various colours of wool (Cheviot or Merino) for decoration**

**Instructions:**

1 Using a handful of white wool tops first smooth the wool out then tightly roll a sausage shape. Add more wool as you go if you need a larger shape. Periodically fold the edges into the shape and continue rolling until the surface is smooth.

2 Lay your shape on to the sponge and carefully needle the ends into place.

3 Turn your shape and needle until it forms a loose ball or sausage shape depending on what you are forming. Don't allow the needle to go all the way through the sponge as it will snap if it hits a hard surface. Also be careful not to stab yourself!

4 Keep turning and needling until you get the shape you want - by needling in the same place over and over you can change the shape.

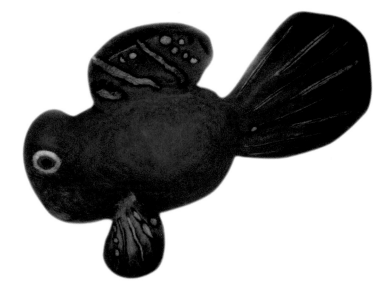

5 When you have a rough shape you can begin to cover it with colour. You can blend the shades by pulling small pieces of wool and mixing them together or you can add stripes or spots, whatever takes your fancy! Attach by laying thin layers smoothed over the surface and needling into place.

6 Keep needling until the shape is as firm as you want it, remembering it will reduce in size the more you needle.

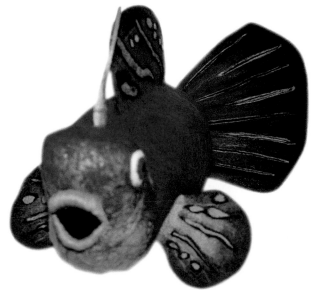

# Silk paper

Silk fibres are one of the lightest, brightest and most beautiful materials that a textile artist can work with. The fibres take Procion or silk dyes, leaving you with a lustrous product that is very strong, even in very thin layers. When layered up with paste or textile medium it is possible to create large textile vessels that are self-supporting.

Silk can be moulded as you would when making papier-mâché, layering small strips or squares of paper with wallpaper paste. My favourite medium for adhering silk fibres is Scola cell paste or CMC paste, which is an extra-strong cellulose adhesive paste that does not contain fungicide. This paste also resists plastic containers so you will not need to cover your mould with cling-film or other resists. The most important thing is to make sure the shape you wish to mould over is wider at the top than the bottom or you will not be able to slide your finished project off.

Below: *Silk Vessels* by Kim Thittichai. Silk fibres moulded over a plastic vase with foiled decoration.

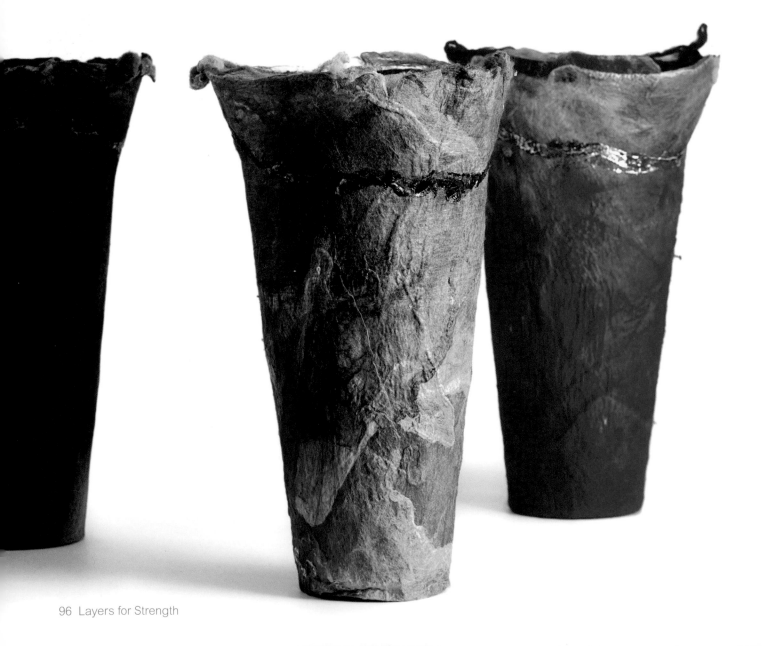

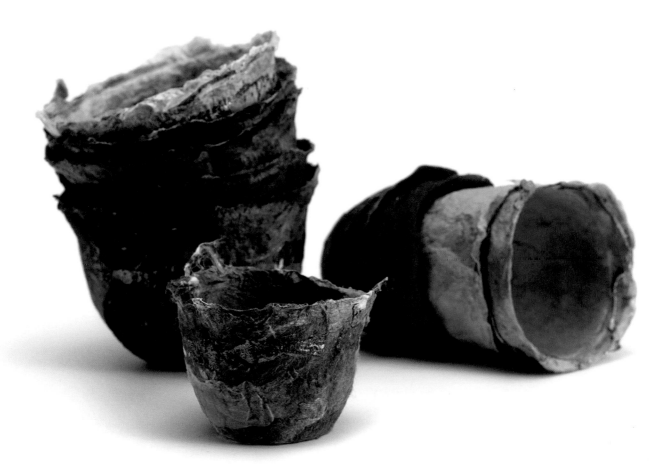

## To make a bowl

The best shapes I have found for small bowls are the plastic pudding bowls that are used for Christmas puddings. These bowls have a narrow base, which makes the silk easy to slip off when dry.

### Instructions:

1  First paint adhesive all over the outside of your bowl.

2  Lay a thin, even layer of silk tops over the paste and use a paintbrush to smooth them out. Leave to dry.

3  Repeat the above procedure five more times. It is very important to let each layer dry before you apply the next. Silk will dry out quickly on a radiator or in the airing cupboard. Of course if you live in a warm climate you could leave it out in the sun.

4  Once you have four or five dry layers on your bowl you can slip it off. It seems as though it won't move at first but if you slide your thumbs down the side of the bowl it should slide off easily once it has loosened.

You now have a light but strong bowl that you can decorate. Try hand stitching around the top of the bowl or applying foil with foil glue. These little bowls make great night-light holders but do be careful never to leave naked flames unattended. Remember: silk will catch fire.

Above: *Silk Bowls* by Kim Thittichai. Silk fibres moulded over plastic pudding bowls with foiled decoration.

# Coiling for strength

I first started coiling bowls and vessels when I majored in ceramics on my degree course. The organic nature of the process appealed to me and became one of the main techniques I employed for my final show. Later, when I started to work with textiles I discovered that many of the techniques used with 'resistant' materials, such as clay, also work well with fabric.

I collect just about anything remotely related to textiles, including old tools, buttons and, of course, beads. I have the most beautiful collection of recycled old, new, big and small beads, all sorted by size and colour. These make lovely wire bowls.

To create a bowl shape you need wire that has a memory – wire that will hold its shape. The wire needs to be thin enough to pass through the holes of the beads you wish to use. Decide on the colour combination you wish to work with and sort your beads before you start. You may also wish to sort by size. Start threading your beads on to the wire and turn the end of the wire to hold the first bead on. Don't cut a length of wire off until you have threaded all your beads, as you may need more wire than you think and it is difficult to join. As you thread the beads, start to coil the wire in an every increasing spiral. The spiral won't hold its shape but you will get some idea of how long you need to make your beaded wire. When you have finished threading your beads, leave an extra inch of wire, cut and wrap around the final bead. To hold your bowl in shape, stitch in between the rows with a strong thread or wire.

Below left: *Baby Pearl* by Kim Thittichai. Vintage pearl and coloured beads threaded on to wire and coiled to make a bowl shape. Held in place with a firm gold thread.

Below right: *Crazy Pink* by Kim Thittichai. Large, brightly coloured wooden beads threaded on to wire, coiled to make a bowl shape and stitched with pink knitting yarn to hold it in shape. The ends were left hanging to make it 'shaggy'.

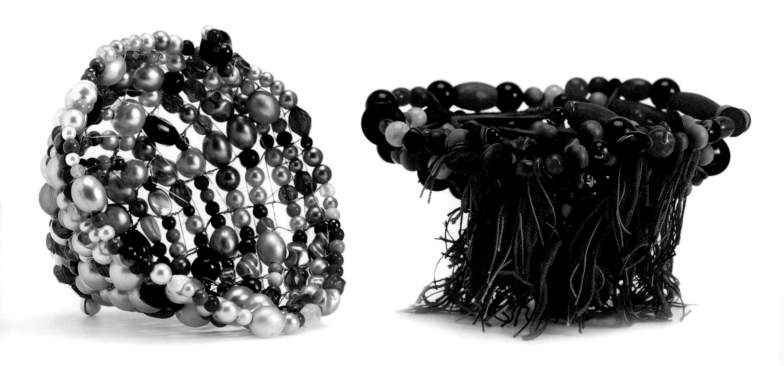

Below: *Amber* by Kim Thittichai
Coloured co-ordinated plastic
and metal beads threaded
on to wire and coiled, held in
shape by stitching with a gold
crochet yarn.

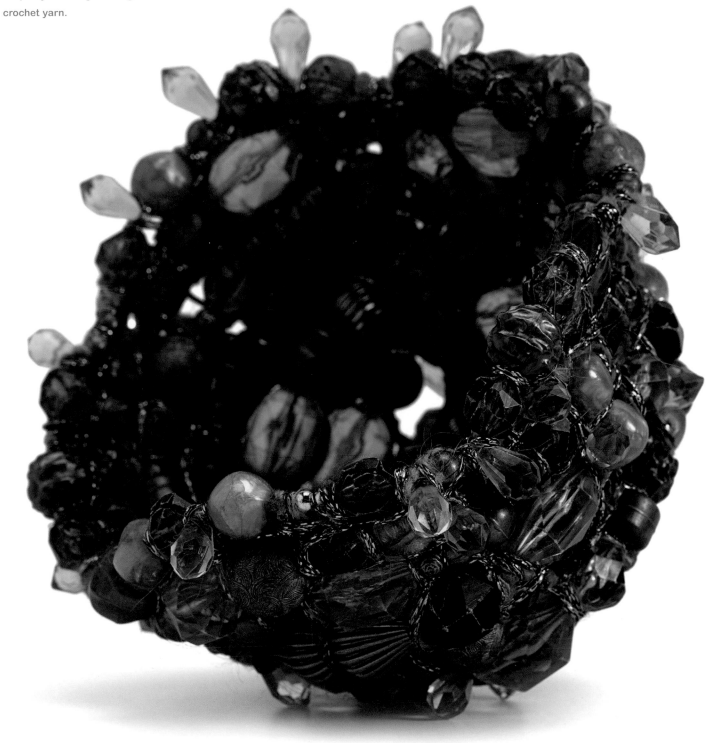

# Finger knitting

Finger knitting is great fun and can be done anywhere – all you need is yarn and your hand. A slip knot is placed over the thumb and the yarn is run in between and around your fingers. As you create the stitches, the knitting falls down the back of your hand in a long tube. Instructions are readily available on the internet.

I first discovered finger knitting when I was teaching a group of special needs students. With funding low I persuaded a local knitting shop to supply old stock for the students to use for stitching into rug canvas. The students needed a lot of assistance to stitch and working on a larger scale enabled them to achieve some excellent results.

One of the students began to wrap the yarn around her fingers in a very organized fashion and started knitting with her hand. I had never seen this before and was fascinated. This caused the students great delight – their teacher was being taught. Everyone decided this was much more fun than the stitching I had planned and eventually we were all happily finger knitting away.

Finger knitting has proved to be a very useful technique. For example, finger knitting with woollen yarn then felting it in the washing machine makes a strong handle for a felt bag. Also, finger knitting with nylon filament or fishing line creates beautiful translucent sculptural forms.

Changing the scale of the knitting will also change its strength and what you can achieve with it. To make this coiled vessel (see left and above) I finger knitted ten hanks of white acrylic Aran-weight yarn, which rolled into a huge ball around a metre (3ft) high. I then finger knitted with the finger knitting, which made it double in size. I then finger knitted twice more to create a length of 1.2m (4ft). After the second stage it was no longer possible to keep the knitting on my fingers and I had to work around wooden pegs in a board.

I then coiled the now very thick length of knitting into a rough cornucopia shape and stitched to hold it in shape. To finish, I decorated the edge with old recycled plastic pearl beads.

Be brave with your layers; experiment. Discover how many layers you can stitch through. Be amazed at how fine but strong fibres can be made into three-dimensional forms. Play – see what happens...

Left and above: *Pearly Queen* by Kim Thittichai. Finger knitted vessel.

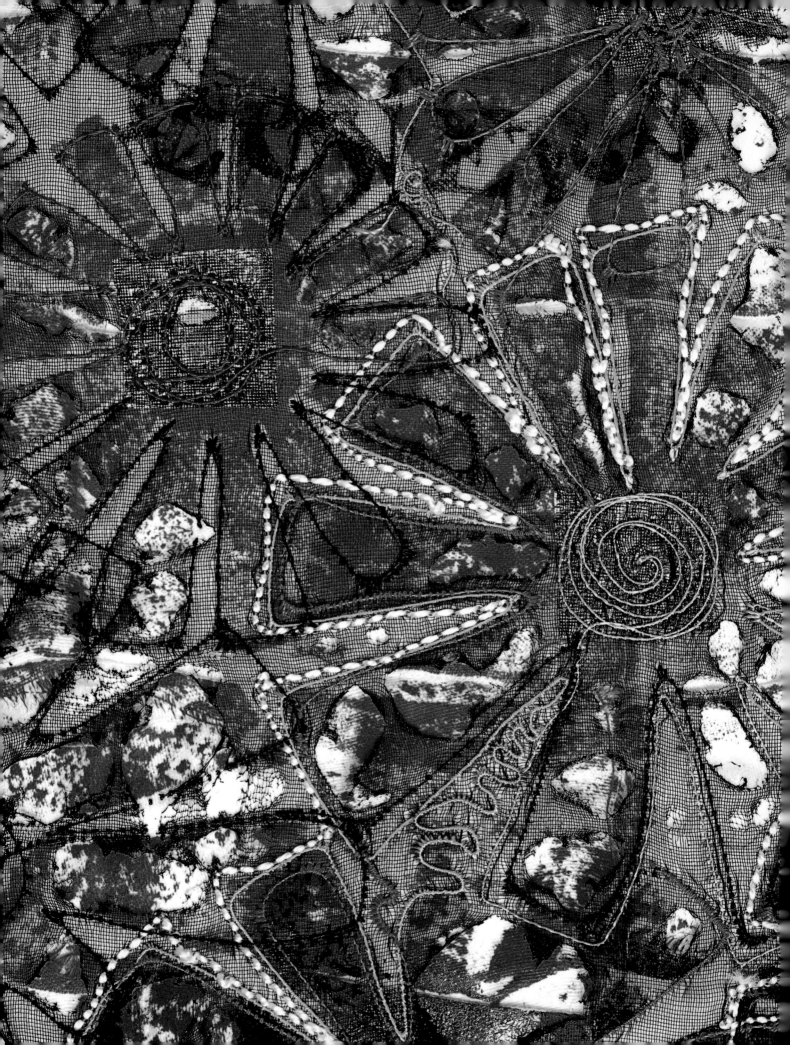

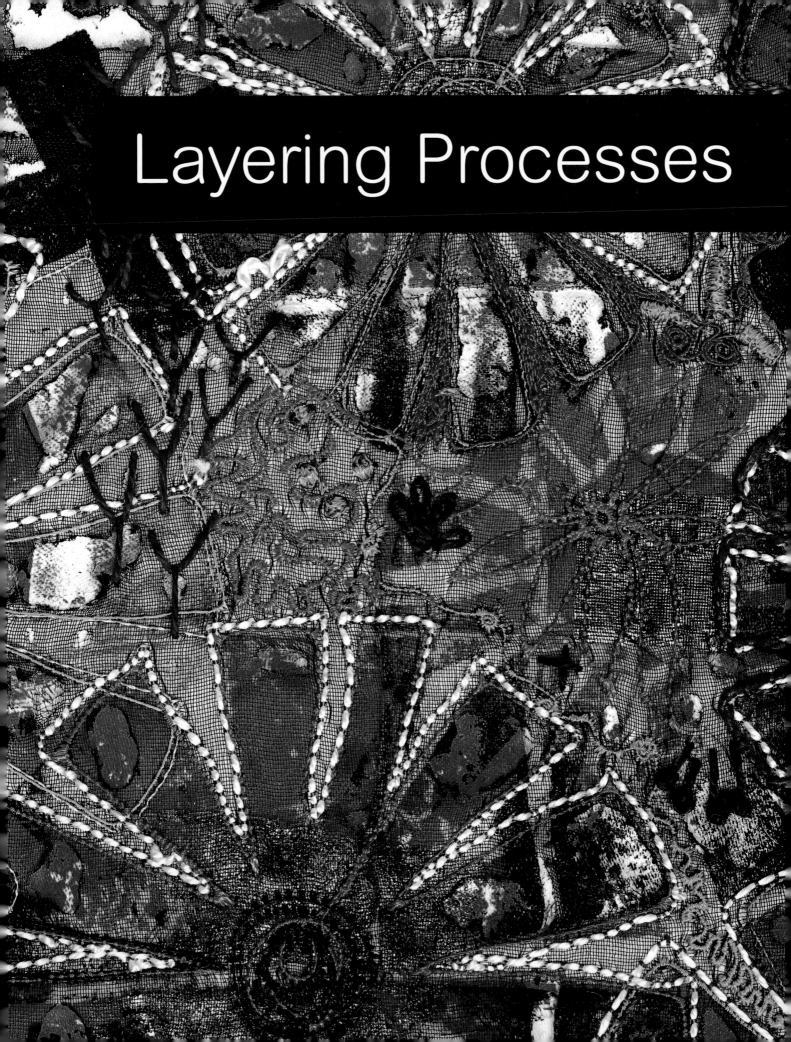

# Layering Processes

# Layering processes

alter, convert, deal with, dispose of, fulfill, handle, make
ready, prepare, refine, take care of, transform, treat

Hopefully, as you have read through this book you will have understood the importance of 'designing through process'. This means understanding the materials you are working with before you can design and complete a finished object. You will have had a chance to make various sample pieces using different processes, which will stand you in good stead for creating your own finished pieces.

## Synthetic or natural?

How do you choose which kind of material you are going to use? One way to start is to divide your fabrics into either synthetic or natural categories. They both have excellent qualities, but which is best for the project you have in mind? Fabrics are made of fibre that either comes from an animal (hair, fur and feathers), a vegetable (such as cotton or hemp) or a mineral (such as fibreglass). Fabric making goes back over 10,000 years; in ancient societies flax was used to create a type of linen.

During the early 20th century, scientists developed a new type of textile using the natural cellulose fibres from plants and petrochemicals to make Rayon, but the first truly synthetic textile was Nylon. Nylon, invented in 1930, was very important during World War II and beyond.

Rayon is the odd one out of all the fibres. Because it is man-made it is thought to be synthetic. Rayon is a manufactured regenerated cellulose fibre. Because it is produced from naturally occurring polymers, it is neither a truly synthetic fibre nor a natural fibre; it is semi-synthetic or artificial. Rayon is also known as viscose and art silk in the textile industry. It usually has a high lustre, giving it a bright sheen. It also creases when you wear it, so behaves like cotton or silk. When you are dyeing or colouring rayon or viscose, treat it as cotton.

Natural fibres you might consider using in your textile work include: angora, camel, alpaca, llama, vicuna, cashmere, cotton, hemp, linen, mohair, ramie, silk and wool. Plant fibres you could use include abaca, banana and pineapple. Natural fabrics can be dyed and decorated with Procion dyes, and can be frayed and torn easily. Natural fabrics cannot be distressed and cut away with a heat gun or soldering iron.

Manufactured fibres include acetate, acrylic, Lyocel, microfibres, nylon PLA fibre (corn polymer), polyester, polyolefin (olefin), Spandex and triacetate. Synthetic fabrics can be distressed and cut away with a heat gun or soldering iron, dyed and decorated with disperse dyes (transfer paints), and often come in very bright, even fluorescent colours. They tend to be very strong but can disintegrate over time when exposed to the sun. Synthetic fabrics cannot be dyed and decorated with Procion dyes and remain colour fast.

All fabrics can be hand or machine stitched, and printed and painted with fabric paints.

Right: Layers of fabric-weight Tyvek and polyester organza machine stitched on to dyed craft Vilene and zapped to create texture. Sections of the design were removed carefully with a soldering iron to create more definition.

# Surfaces

Very encrusted and distressed surfaces can be developed when working with synthetic fabrics. Combining the use of a soldering iron with a heat gun can create fantastic textures. Once you have layered up your synthetic fabrics and stitched them together, you can distress the entire surface with the heat gun, exposing different layers as you work. Then take out sections very carefully with a fine-tipped soldering iron. This is my cheeky version of reverse appliqué.

While complicated-looking surfaces can be exciting, don't forget that simple ways of working can be just as effective. Using painted Bondaweb as a background to iron on simple shapes can create a stunning piece of work; keeping things simple can sometimes be best. Start with basic layers and build up slowly. It much easier to add layers than take them off at a later date.

Below: Layers of fabric-weight Tyvek, Vilene Spunbond and polyester organza stitched to a background of dyed craft Vilene. The whole sample was zapped with a heat gun to create texture then areas of the design were removed to add definition.

# Evolon/Evo 80

Evolon, trade name Evo 80, is a combination of polyester and polyamide and can be dyed, printed, cut and sewn, the same as any traditional textile. This fabric can be cut with a soldering iron and will eventually distress with a heat gun but this can take some time! Evolon is a unique microfilament. Like traditional microfibres it is soft, drapeable and light, but it is also very strong. It is very absorbent, but quick to dry and breathable.

Transfer or disperse dyes work particularly well on Evolon because of its absorbent qualities; the fabric sucks the dye off the paper leaving a strong, bright print. As Evolon only comes in white at the moment it does need to be coloured unless you want a plain, white look. Once the fabric has been coloured you can then print on to it, cut it with a soldering iron and distress it, but you probably will not want to use all these processes on the same piece of work.

Below: Transfer printed Evolon printed with Xpandaprint, which was expanded by zapping with a heat gun. This process also started to distress and texture the Evolon. The Xpandaprint was then painted to merge into the background.

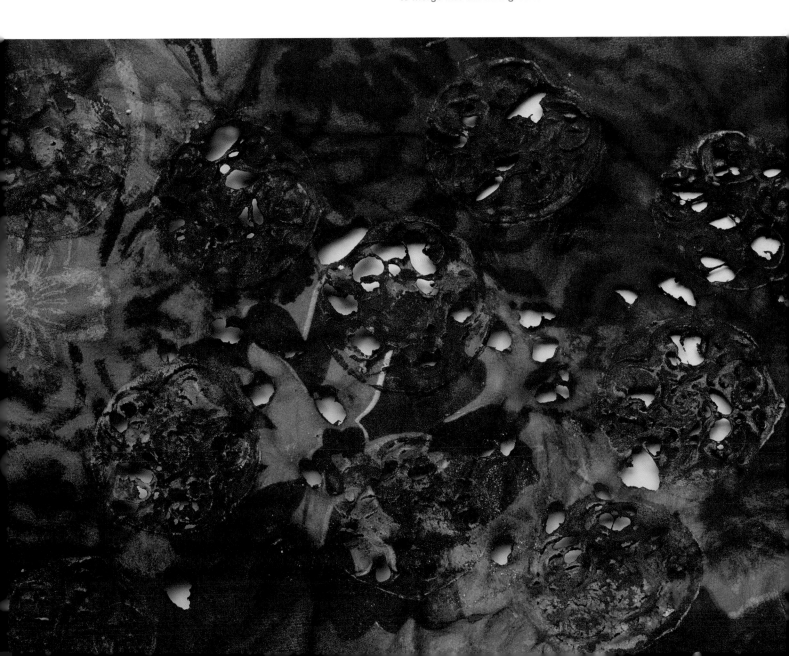

# Angie Hughes

Angie Hughes is a textile artist and tutor. She won the prestigious Charles Henry Foyle Trust Award for Stitched Textiles with her piece *Unfolding Word* and had *Shroud* accepted for Art of the Stitch. Her artwork is inspired by many themes but particularly poetry or text and the natural world, especially plant forms.

*Red Daisies* (see page 110) was an experimental piece using scraps of undyed calico to weave a new fabric to work on. Angie made flowery printing blocks from Plastazote, a heat impressible foam, and printed a background using acrylic paints. There are squares of heat-transfer foil on Bondaweb and foil sweet wrappers placed in the middle of some of the flowers for that extra bit of glitz. The whole piece was then covered with polyester organza and stitched around the shapes with free machine embroidery with Angie's favourite 'whip' stitch. The organza was then distressed with a heat gun and the piece was finally decorated with hand stitch.

*Book Wrap* (see right) as Angie's first sample of the woven techniques she used in *Red Daisies*, woven, printed then stitched. Angie discovered that too much stitch caused the whole piece to shrink and she had to add an extra piece on the end and cover it with buttons to hide her error. It then fitted the book. This shows the importance of trying out samples of your layered processes to discover just such problems.

Angie's current work, such as *Buds in Bloom II* (see page 111), is inspired by wild gardens and plants weaving between each other. She enjoys the juxtaposition of randomly 'placed' wild plants alongside the order the gardener tries to maintain. Imagining these gardens in shadowy moonlit illumination, Angie's use of colours has become almost monochromatic; silvers and blacks and those hard-to-name colours that arise when light has faded. From drawings and photography Angie has developed her visual ideas through embroidery, inventing simplified botanical forms. This recent work has seen her explore discharged and painted velvets, using heat-transfer foils and layered organza, which is intensely machine embroidered.

Angie used a cotton velvet, coloured and discharged using Dye-Na-Flow dyes and ink. This was overprinted using Indian print blocks with acrylic paint. The 'stalks' of the plants are made from foiled Bondaweb with sprinklings of glitter. Inspired by the work of Klimt, Angie usually adds squares of foil sweet wrappers attached with Bondaweb. The surface of these pieces was covered with polyester organza and free machine embroidered in place around the design elements. The organza was then distressed away with a heat gun.

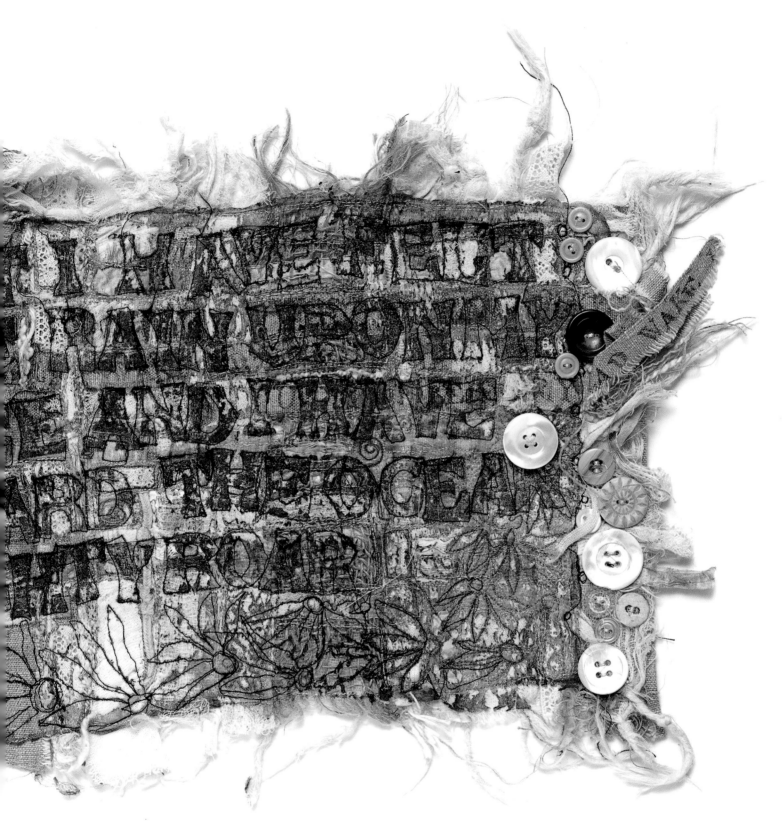

Above: *Book Wrap* by
Angie Hughes.

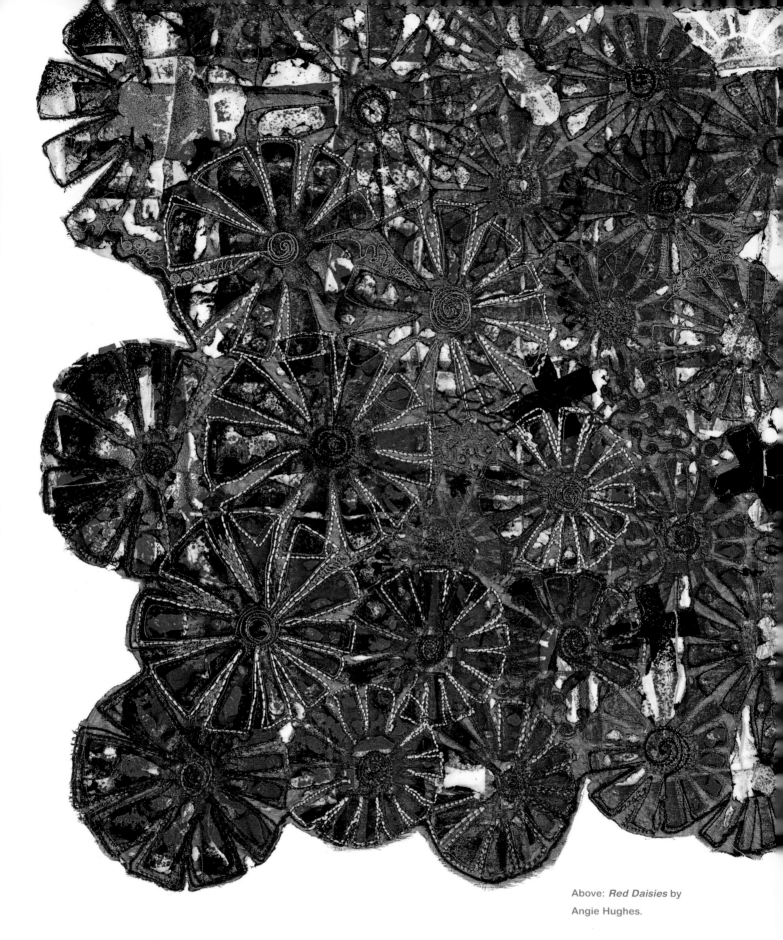

Above: *Red Daisies* by
Angie Hughes.

Right: *Buds in Bloom II*
by Angie Hughes.

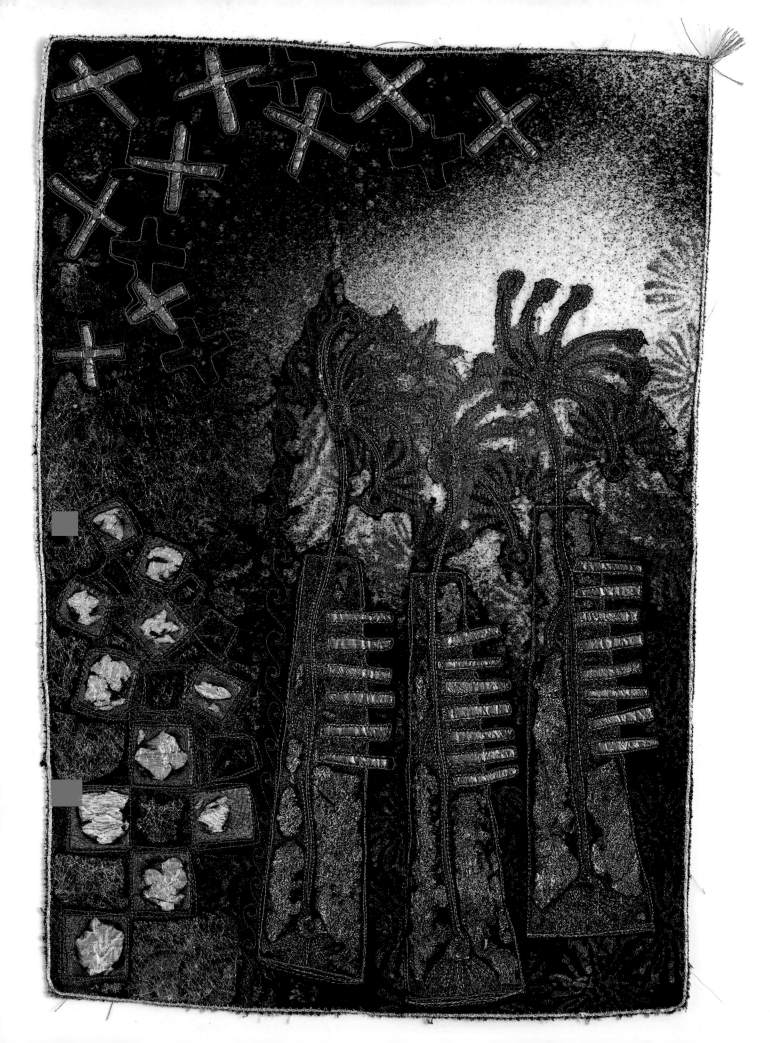

# Laser cutting

The way we cut fabrics has developed rapidly over the past ten years. Textile artists now have access to many types of machinery that can change how we use our finished work. There are now die-cutting machines that cut fabric, which remove the need for the time-consuming and repetitive cutting out by hand. These machines will also cut fabric that has Bondaweb bonded to it so appliqué designs can be cut quickly and accurately.

The most exciting machine for me is the laser cutter. Your design is transferred from a computer to the laser cutter via a USB print cable. It couldn't be simpler. The design is so sharp and accurate, and the results are quite incredible. Many schools and colleges have these lase cutter machines and the exciting work that is coming out of these centres is wonderful.

Laser cutters are usually used to cut acrylic and wood but they are being increasingly used with textiles. I have tried cutting very heavy iron-on interfacings, Evolon and acetate satin backed with Bondaweb and have had good results with all of them. These machines are very expensive but it may be possible to negotiate time on one at your local college.

Left and right: Transfer-printed craft Vilene with Bondaweb ironed on to the back, cut with a laser cutter. Decorated with Evolon, which is also transfer printed and cut with a laser cutter.

# Wendy Dolan

Wendy Dolan trained in art and textiles, and specializes in freehand machine embroidery and related creative stitching techniques. I have chosen two of Wendy's latest layered pieces to demonstrate working with layered natural fabrics.

Venice is a wonderful source of inspiration for artists and a recent visit to this magical destination gave Wendy plenty of opportunity for design. She particularly enjoys exploring surface texture and loves the contrast between crumbling brickwork and plaster walls, ornate decorative balustrades, railings, doors and windows. This variety makes the architectural elements of the city so inspiring. Sketches and photographs are used to record textures and images. Back in the studio Wendy develops her observations using a variety of media – pen and ink, pastels and paper or fabric collage. Only then does Wendy start to interpret her ideas into stitched textiles.

*Venetian Façade* (see left) was created using a combination of techniques. A variety of cotton fabrics were selected, representing the textures within the design. These were then pieced, patched and layered, and then worked into with hand and machine stitching. To produce more surface texture, nappy liners were applied and Xpandaprint sponged on to the fabric. A hot air gun was worked carefully over this, creating exciting surfaces, which contrast with the smoother layers of fabric. Fresco Flakes (matt flakes that resemble real bits of peeling paint) were also applied to the background. The design was then painted using Sericol fabric inks. Further embellishment and detail were added with machine and hand stitching using coloured threads. The resulting design shows an exciting range of textured layers, demonstrating how versatile stitched textiles can be.

*Brighton Sea and Downs* (see opposite) is from a series working on the theme 'A Sense of Place'. We all have memories of special places we have visited throughout our lives and these designs represent some of Wendy's memories. Landscapes have always been an important source of inspiration in her work and she enjoys exploring the textural elements that surround us.

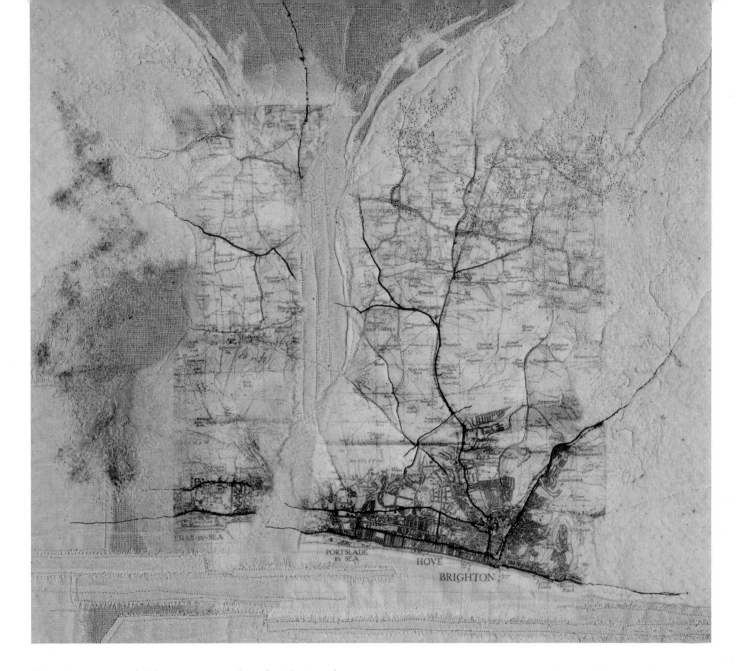

Here, fragments of old maps are combined with pieced, patched and layered fabrics including calico and scrim. Freehand machine and hand stitching are used to define textural elements. The contours of the land are extended beyond the map using stitch, along with roads, the sea and other topographical elements. Surface texture is further enriched by applying three-dimensional fabric mediums and working into the layers with an embellisher machine.

When Wendy first started working with maps, she was careful to work within copyright restrictions when sourcing maps needed for her work. Always check if there are copyright issues when using images other than your own, even maps. Even if you change the design slightly you may be in breach of copyright. If possible, it is always best to work from your own images, drawings and photographs.

Above: *A Sense of Place: Brighton Sea and Downs* by Wendy Dolan.

Left: *Venetian Façade* by Wendy Dolan.

# Sue Munday

Sue Munday is a textile artist and tutor and is a specialist in free and computerized machine embroidery. She has been experimenting with Bondaweb and good-quality acrylic felt for some time. This was Sue's first experimental piece before she moved on to creating wearable items; although this particular piece is not wearable it gave Sue lots of ideas to develop.

Sue digitized the design of a feather she had downloaded from an embroidery site for digitized designs. Sue then loaded the design into her Janome digitizing software, and was then able to enlarge, reduce, omit and add parts to the design to her satisfaction. Once pleased with the design Sue prepared the layers of fabric in an embroidery frame for stitching out. She machine stitched a large feather on to organza, and this became her 'printing block'. She removed the excess organza and applied the feather shape to a foam block.

Painted Bondaweb was ironed on to a white felt base. Using the feather printing block Sue printed on to the base fabric, and to some of the images she also applied embossing powder to give a slightly raised effect. Stitching was then applied, using a twin needle to give the effect of 'boning', and stability. The central panel was constructed from layers of organza and then stitched with a selection of varying sizes of the feather in a prepared design layout, and repeated along the length of the panel.

The frilling trim was constructed from part of the large feather laid on its side and then linked sideways, stitched out repeatedly on to organza and the excess burned away with a fine-tipped soldering iron to give a wonderful curling edge.

The lining was also stitched on felt with a top layer of cream silk, and again stitched with the twin needle.

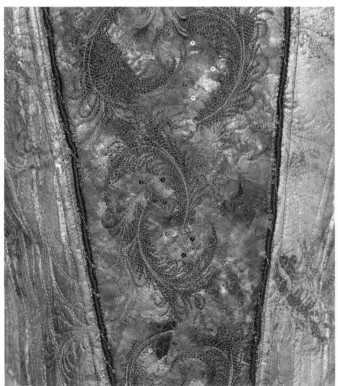
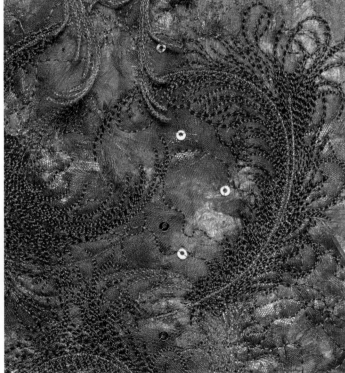

Above and left: *Flighty Corset*
by Sue Munday.

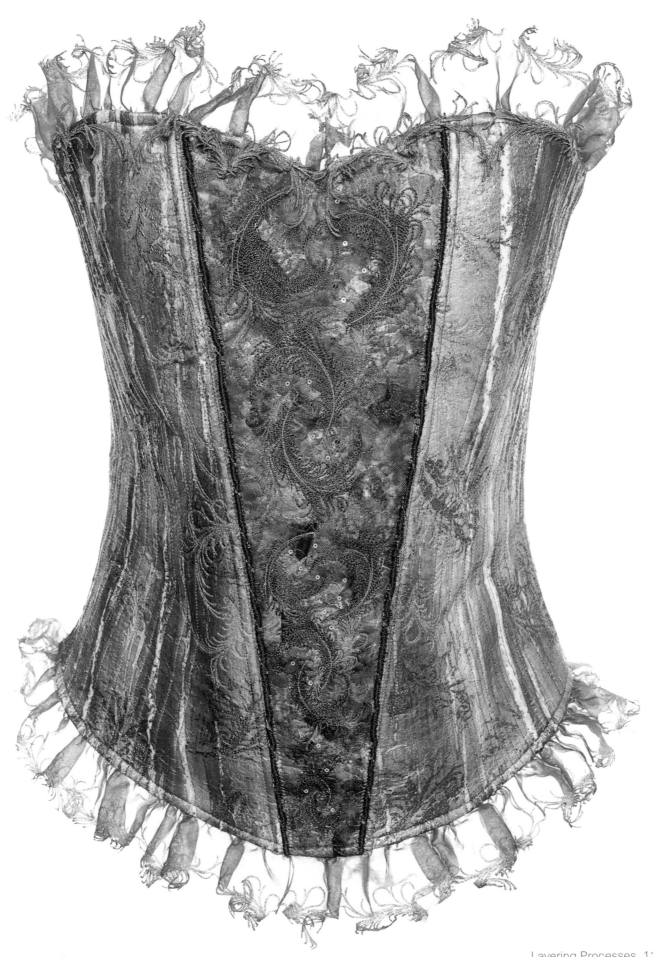

# Conclusion

I hope that this book gives you food for thought. My main reason for writing *Layered Textiles* was to encourage you to think about all the techniques and processes you already know and for you to discover how you can layer many of them together to create something fantastic. If you are not sure about how much is too much, stick to a limited palette of colour and use lots of texture. Alternatively, use many layers of colour but keep the texture to a minimum.

Keep looking about you. There is so much to inspire us at unexpected times. Think of the layers in music – rhythm, melody, the sequence instruments are played in, whether the music is fast or slow, loud or soft. Passing a flower bed with an exotic display of unusual colours together. Having a camera on your mobile phone is very handy for recording information but do ask permission if you are taking a photograph of someone or their work.

There has never been a more exciting time to be working in textiles, with so many different age and experience ranges practising at the same time – wonderful things are happening. We can all learn from each other, young or old and we will never stop learning. I can't urge you strongly enough to visit exhibitions and galleries, whether they are local or further afield. Make notes of what you like and don't like, and then try to work out why. The main thing is to just keep looking and thinking...

Layers can give strength, be transparent, textured, soft, hard and colourful. See what you can achieve with the help of this book and a bit of inspiration.

Right: *Slippery Stripes*
by Kim Thittichai.
Layers of Vilene
Spunbond CS700,
ironed on to CS800
and hand stitched.

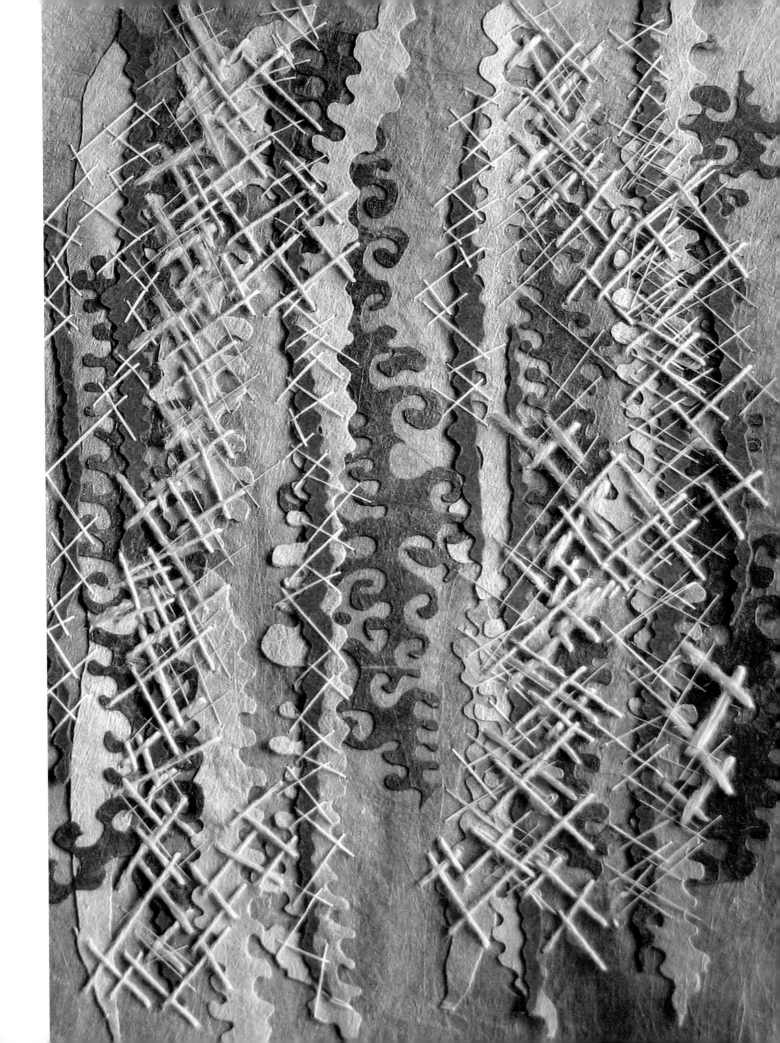

# Featured Artists

**Kim Thittichai**
www.kimthitticihai.com

**Clare Rose**
www.clarerosedesigns.co.uk

**Wendy Dolan**
www.wendydolan.co.uk

**Angie Hughes**
www.angiehughes.com

**Fay Maxwell**
www.fayandkay.co.uk

**Jayne Routley**
www.ladylazarus.co.uk

**Sarah Lawrence**
www.craftynotions.com

**Lee Brown**
www.leebrowndesigns.co.uk

**Isobel Hall**
isobelhall@gmail.com

**Ann Small**
www.asmalldesign.co.uk

**Cherrilyn Tyler**
www.cherrilyn.com

**Sue Munday**
www.suemunday.co.uk

**Doreen Woodrow, Alix Mercer-Rees and Sylvia Lynton**
contact via Kim Thittichai:
info@kimthittichai.com

Right: *Buds in Bloom I*
by Angie Hughes.

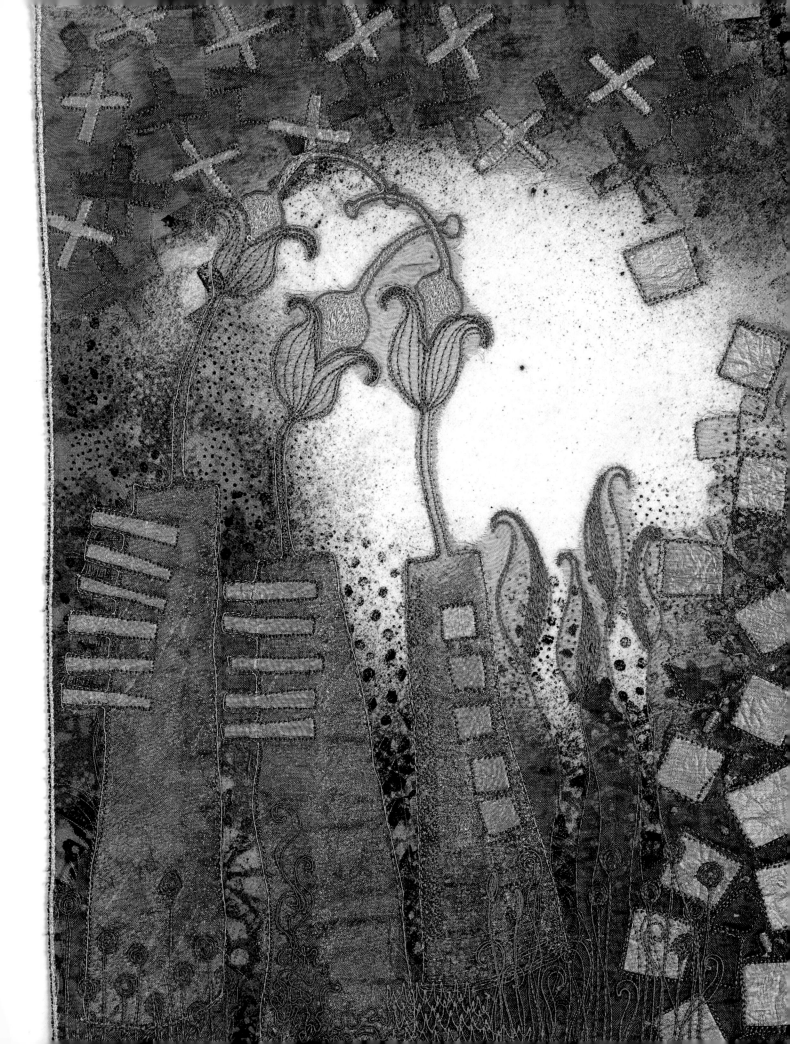

# Useful Addresses and Suppliers

The companies below sell everything you could possibly need and things you never knew you needed, including silk fibres, paints, dyes and Xpandaprint.

**nid-noi.com**
126, Noriwch Drive
Brighton
BN2 4LL
www.nid-noi.com
*(Suppliers of Tyvek, Vilene Spunbond, Craft Vilene, Bondaweb, Solo-fleece, heat-transfer foils and Lamifix)*

**Texere**
Texere Yarns Ltd
College Mill
Barkerend Road
Bradford
BD1 4AU
www.texere-yarns.co.uk
*(An amazing selection of yarn)*

**Whaleys (Bradford) LTD**
Harris Court
Great Horton
Bradford
West Yorkshire
BD7 4EQ
www.whaleys-bradford.ltd.uk
*(Suppliers of black cotton and polyester satin and hundreds of other fabrics)*

**Margaret Beal**
www.margaret-beal.co.uk
burningissues@margaret beal.co.uk
*(Soldering irons and fabrics)*

**Ario**
Garngcoch Workshops
Unit 9
Pheonix Way
Gorseinon
Swansea
SA4 9WF
www.ario.co.uk
*(Dyes, fabric paints, Tyvek, handmade papers, fabrics and much more)*

**Art Van Go**
The Studios
1 Stevenage Road
Knebworth
Hertfordshire
SG3 6AN
www.artvango.co.uk
*(Art and textile products, materials and techniques)*

**Craftynotions**
Unit 2
Jessop Way
Newark
NG24 2ER
www.craftynotions.com
*(Materials for dyeing, embossing, working with fibres and fabrics, embellishing and more)*

Right: A selection of materials used for the flower sample by Sarah Lawrence (see page 22).

# Useful blogs & other websites

**Kim Thittichai's blog**
www.hot-textiles.blogspot.com

**Angie Hughes's blog**
www.angiestextilenotes.blogspot.com

**The Textile Study Group**
www.textilestudygroup.co.uk

**Workshop on the Web**
www.workshopontheweb.com

**Bobby Britnell**
www.bobbybritnell.co.uk
*(Bobby runs various workshops with Ruth Issett)*

**The American Museum, Bath**
www.americanmuseum.org
*(A wonderful collection of old quilts and rag rugs.
Check for opening times)*

# Further Reading

Beal, Margaret, *Fusing Fabric: Creative Cutting, Bonding and Mark-making with the Soldering Iron* (Batsford, 2007)

Beany, Jan and Littlejohn, Jean, *Stitch Magic: Ideas and Interpretation* (Batsford, 2005)

Beany, Jan and Littlejohn, Jean, *A Complete Guide to Creative Embroidery: Designs, Textures, Stitches* (Batsford, 1997)

Edmonds, Janet, *From Print to Stitch: Tips and Techniques for Hand-printing and Stitching on Fabric* (Search Press, 2010)

Grey, Maggie and Wild, Jane, *Paper, Metal and Stitch* (Batsford, 2007)

Hall, Isobel, *Bags with Paper and Stitch* (Batsford, 2007)

Hall, Isobel, *Embroidered Books: Design, Construction and Embellishment* (Batsford, 2009)

Hall, Isobel, and Grey, Maggie, *Mixed Media: New Studio Techniques* (D4daisy, 2010)

Holmberg, Nanette, *Variations in Chenille: Techniques for Creating Faux Chenille* (That Patchwork Place, 1997)

Hughes, Angie, *Stitch, Cloth, Paper and Paint: Mixed Media Ideas and Inspiration* (Search Press, 2008)

Issett, Ruth, *Colour on Cloth* (Batsford, 2009)

Issett, Ruth, *Print, Pattern and Colour* (Batsford, 2007)

Lawrence, Sarah, *Silk Paper for Textile Artists* (A&C Black, 2008)

Smith, Sheila, *Felt to Stitch: Creative Felting for Textile Artists* (Batsford, 2006)

Thittichai, Kim, *Hot Textiles: Inspiration and Techniques with Heat Tools* (Batsford, 2007)

Thittichai, Kim, *Experimental Textiles: A Journey Through Design, Interpretation and Inspiration* (Batsford, 2009)

Right: Detail from *Delicate Decay* by Doreen Woodrow (see page 66)

# Index

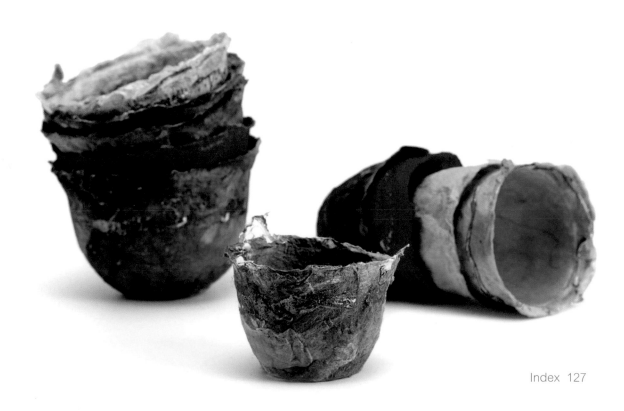

# Glossary

**Acrylic wax:** a milky liquid that dries clear and waterproof. A great way to seal your work.

**Allum:** used as a mordant when colouring fabric with natural dyes.

**Baking parchment:** a non-stick baking paper used on top and underneath your work to stop it sticking to the iron.

**Bondaweb/Vliesofix:** a thin layer of heat-fusible glue on a paper carrier sheet. Can be painted.

**Embossing powders:** generally used in card making, powders are sprinkled into inks or glue and expanded or melted with a heat gun.

**Hot Spots!:** spots of glue on a firm brown paper backing. Can be cut with scissors, a hole punch or a die-cutting machine.

**Interfacings:** A range of stabilizers used to support anything from collars in dressmaking to tie backs in soft furnishing. Interfacings can be iron-on or sew-in.

**Lamifix:** an iron-on laminate sheet that comes in matt or gloss.

**Mod Podge:** a great product for any kind of craft, used as a glue, varnish or sealer.

**Mordant:** most natural dyes need a mordant, such as alum, to fix the colour to the fibre and increase lightfastness.

**Pelmet Vilene/Craft Vilene:** a firm interfacing generally used in soft furnishings but brilliant as a support for textiles projects. Can be iron-on or sew-in.

**Solufleece/Soluvlies 321:** a water-soluble stabilizer for free machine embroidery.

**Stabilizer:** any product that supports your work.

**Texture gels and mediums:** Can be used as a glue, varnish or sealer. Texture gels come in many thicknesses and effects.

**Vilene spunbond:** comes in various weights and colours. Can be cut with a soldering iron and distressed with a heat gun.

**Xpandaprint:** a thick, creamy medium that can be applied with a brush, roller or sponge. It expands when heated, can be painted and it is non-toxic. A 'puff paint' or heat-expandable printing medium.